Tales of Old Nottinghamshire

Other counties in this series include:

Avon
Bedfordshire
Berkshire
Buckinghamshire
Cambridgeshire
Devon
East Anglia
Essex
Gloucestershire
Hampshire
Herefordshire
Hertfordshire
Kent
Leicestershire

Lincolnshire
Norfolk
Northamptonshire
Oxfordshire
Shropshire
Somerset
Stratford
Suffolk
Surrey
Sussex
Warwickshire
Wiltshire
Worcestershire

Tales of Old Nottinghamshire

Polly Howat

With Illustrations by Don Osmond

COUNTRYSIDE BOOKS
NEWBURY, BERKSHIRE

First Published 1991
© Polly Howat 1991

COUNTRYSIDE BOOKS
3 CATHERINE ROAD
NEWBURY, BERKSHIRE

ISBN 1 85306 160 3

Produced through MRM Associates Ltd., Reading
Typeset by Wessex Press Design & Print Ltd., Warminster
Printed in England by J. W. Arrowsmith Ltd., Bristol

For Robert and Phylis Howat

Acknowledgements

With grateful thanks to the staff of the Local Studies Department, Nottinghamshire County Library; the Nottinghamshire Local History Association; J. G. Staley Esq, C.Eng, M.I.Mech.E; Mr Jim Worgan, Keeper of Collections, Chatterley Whitfield Mining Museum.

Contents

CONTENTS

NOTTINGHAMSHIRE – The map overleaf is by John Speede, and shows the county as it was in the early seventeenth century.

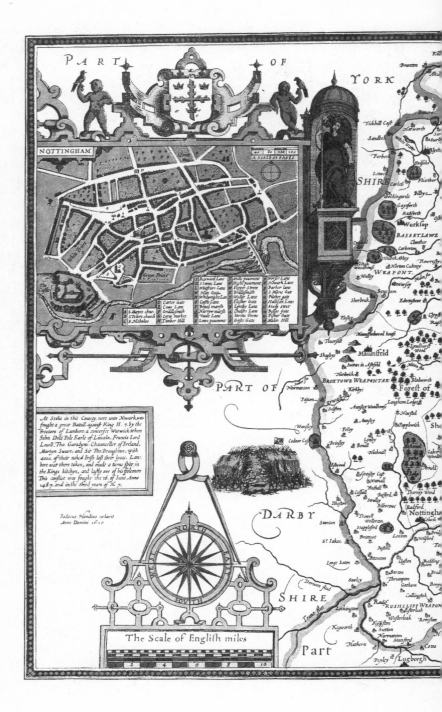

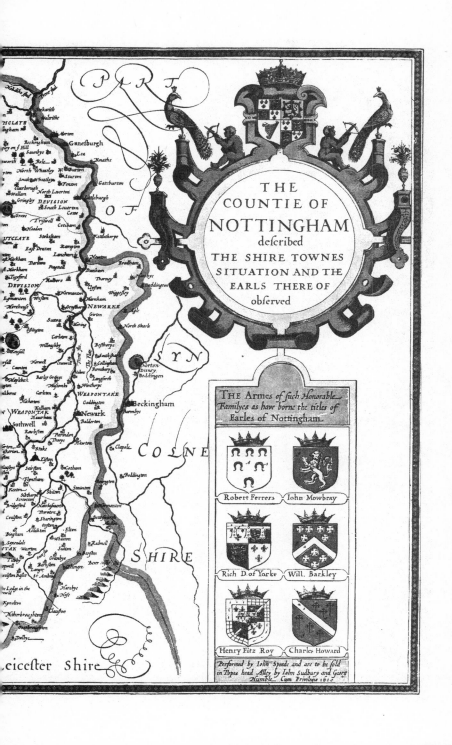

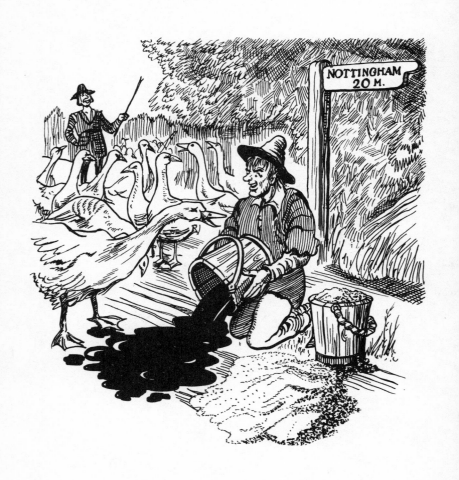

The Nottingham Goose Fair

THE Goose Fair, which now starts on the first Thursday in October and lasts for three glorious days, dates back to the 13th century.

In those days the Nottingham Fair was definitely the poor relation of the one held at Lenton Priory, which was a major event lasting twelve days, starting on the Feast of St Martin, 11th November. However, as Nottingham gradually expanded into a major industrialised area, its fair superseded Lenton's.

Until the end of the Middle Ages most trade conducted in this country and with foreign merchants was undertaken at fairs. Foreigners were restricted from selling in chartered towns so fairs were ideal venues, where money earned from their sales was used to purchase goods for export.

At the major fairs booths were set out in 'streets' such as Booksellers Row, Cloth Row or Fair, Tanners Row, Skinners Row and similar. In addition there was always a large Horse Fair. Not all traders could afford the luxury of cover and hawked their wares from back packs. They were prohibited from walking round making sales as this would have made it difficult for the fair owners to collect their rents.

It seems that the term 'Goose Fair' first appeared in 1541 and there are various apocryphal tales which claim to give the origins of the name. For instance there is a story told in ballad form, wherein a widower who reared his one son in total seclusion from women, took the lad to Nottingham Fair when he reached the age of majority. On seeing women for the first time the boy enquired: 'Father, what are these?' 'Birds,' said the flustered father, 'they're called Geese!' Word got out about the lad's first experience of women and the fair became known as the Goose Fair!

Another old story tells of an angler who was fishing in the river Trent, a mile or two out of Nottingham. He felt a tugging at his line and jerked it high into the air, with a good-sized pike caught on the hook. A wild goose happened to be flying overhead, grabbed the fish and took the angler with him. When the bird flew over Nottingham Market Place — the old venue of the fair — he dropped his booty of man, fish and tackle. The fisherman got up, unharmed, and to celebrate his good fortune a holiday was proclaimed.

A more plausible reason for the name is the fact that thousands of geese were driven up from the Lincolnshire Fens and even parts of Norfolk, to be sold in Nottingham's Market Place at Michaelmastide. The birds had to walk long distances to reach Nottingham and so the gooseherds who drove the flocks would make them walk through alternate patches of wet tar and sand to preserve their feet. In effect the tar and sand mixture acted as little marching boots for the birds, who could easily manage ten miles a day. Obviously when they reached their final destination they had to have a good rest and plenty of food to regain the weight they had lost in their travels, although they would have grazed on the fields en route to Nottingham.

To eat a goose on Michaelmas Day was once considered by Nottinghamshire folk to be very lucky, for as the saying goes:

'He who eats goose on Michaelmas Day,
Shan't money lack his debts to pay.'

It was also customary for landlords to receive presents from their tenants of a goose, which at that time of the year was at its perfection, having liberally grazed on the stubble fields.

Although goose was the prime commodity at the old fairs, cheese was another important factor. In about 1766 the farmers increased the price per pound by one third of that charged at the previous fair, thereby demanding from 28 shillings to 30 shillings a hundredweight. The 'Great Cheese Riot' ensued. Cheeses were hurled at the cheesemongers, whose stalls were ransacked and plundered. The mayor tried to cool tempers but ended up being knocked out by a huge cheese which was aimed straight at him. A great number of cheeses were rolled down Wheeler Gate and Peek Lane and matters got so out of control that the dragoons were summoned. The riot was quelled, but not before blood had been shed. One man named William Eggleston, while guarding some stock, was killed on the spot by the fire of a dragoon and others received serious injuries. Although a lot of people were arrested they were eventually released.

At one time you could buy almost anything at the fair, even wives were auctioned off! This was a common occurrence at many fairs throughout the country, when the womenfolk were put up for sale, each being obliged to wear a horse's collar.

The Horse Fair was also an important part of the event and the yearling ponies, which were brought from as far away as the New Forest, Wales and the Lake District, always sold well. Often the sellers 'oiled the wheels of commerce' by supplying beer to dithering customers to help them make up their minds. An article appeared in the *Nottingham Journal* in 1901 concerning a coal man who took his ancient horse called Bob to the fair to exchange it for a

better nag. Whilst tipsy he purchased a horse called Phillip, who was 'worth 50 guineas', for just £20, with poor old Bob thrown in to clinch the bargain. When he got home and eventually sobered up he discovered that he had bought back his original almost worthless horse, which now had a new name and painted feet.

On 5th May 1840 the railway line linking Nottingham with Leicester was opened. Over the years the rail network was extended and this helped swell the number of people who flocked to the fair. Before the turn of the century it was estimated that the railway was responsible for bringing in some 58,000 people during the event.

The train also brought in the fantastic Bostock & Wombwell Menagerie which was one of the highlights of the fair. Weeks before the Goose Fair most children made sure that parents and neighbours had jobs to be done and errands run for a farthing or a halfpenny so they could spend their earnings over those three glorious days.

Most had to be content with just a little money and a few treats, but they still enjoyed the hurly-burly of that time. They inhaled the smell and soaked up the sound of the giant traction engines which disgorged billows of steam from their fiery bellies. Young girls screamed and swooned into the arms of their sweethearts. Squeals and giggles also came from many shadowy areas, for the Goose Fair had a reputation for its 'slap and tickle'. Even more so when it moved to The Forest with its good covering of trees and bushes! Many young women went home with permanent souvenirs.

There was an abundance of food, such as hot mushy peas wiped up with 'more gravy an da chunk of bread' (sic). Also popular were Grantham Gingerbread, brandy snaps, cockles and whelks, and toffee apples. Who could resist those delicious smells which permeated the cool autumn air, especially the chip stalls which sold their finger-burning delicacies in 'paper boats'.

There were always freaks to be gawped at in their booths, like the bearded lady and a very tall chap who looked like a lamp post and was sometimes accompanied by his two midget friends. There were gentle rides and fearsome ones such as the 'steamboat', which swayed back and forth to dizzy heights and agonising dips. This was where the bigger boys congregated on the Sunday just before the amusements were dismantled, and searched for the coppers which had fallen out of people's pockets as they flew through the air.

Besides lots of rides and amusements, other attractions included boxing booths where you could pay the price and challenge the 'pro'. If you survived three rounds you won ten shillings. There was a Wild West Show, a reptile exhibition, and trading stalls which spread out into the town. To a child brought up to expect little, these three days were like Christmas and your birthday rolled into one.

The most exciting, and expensive, time to visit the fair was at ten thirty on the Saturday night, one and a half hours before closing time. The place was so packed you could hardly move, but the atmosphere was electrifying.

In 1928 the Goose Fair moved from the Market Place to a much larger site at The Forest. The old venue was needed for redevelopment. A new extended civic centre, to be known as the Parliament Building, was scheduled for this site, along with adjacent offices and shops. It is said that one lunch time in 1927 when the builders were working on the foundations, suddenly a huge army of rats, lead by a massive King Rat, came out of the diggings, walked across Slab Square and up King Street to where the post office used to be. The column of rats was so long that it stopped the trams.

Of course the geese have long ceased to waddle their way in their makeshift foot gear along the poor roads and mud tracks. Indeed a goose at the Goose Fair now has quite a different meaning! Neither is the bird any longer

traditional Michaelmas food. The combustion engine has killed off the need for a Horse Fair, but what was once described as 'The Finest Market Place in England' has survived and is now a pleasure fair.

The
Battle of
East Stoke

FOR nearly 100 years the families of the great Houses of
York and Lancaster fought to secure their rival claims
to the throne. The death of King Richard III, the head of
the House of York, at Bosworth, Leicestershire, in 1485
and the accession of Henry VII, the head of the House of
Lancaster, marked the date at which for England, medieval
history ended and modern history began. However, the
battle of East Stoke which was fought in Nottinghamshire
two years later could be considered the last act of the Wars
of the Roses.

The battle was the result of a Yorkist plot to unseat the
new king, Henry VII, and restore the House of York by
supplanting him with the young pretender, Lambert
Simnel, who claimed to be Edward, Earl of Warwick, son of
the murdered Duke of Clarence, and nephew of Edward
IV and Richard III. The real Warwick had been
imprisoned in the Tower of London where he was believed
to have died.

Simnel, said to be the son of an Oxford joiner, was the
pupil of a young priest named Richard Symonds, one of
the architects of the plot, who believed that if successful
Lambert would make him Archbishop of Canterbury.
There was a great deal of Yorkist support in Ireland and

Lambert was shipped off to that country by Symonds and his conspirators. Simnel's claim was accepted by Edward IV's sister, Margaret Dowager Duchess of Burgundy and by other Yorkist sympathisers.

On the 24th May 1487, Simnel was crowned as Edward VI in Dublin Cathedral. New coins were struck, a Parliament was convened and plans made to invade and conquer England. The Duchess of Burgundy provided 2,000 German mercenaries for the cause, and a force of poorly armed Irish levies was raised in preparation for an English battle. The Earl of Lincoln was in charge of these forces and his second in command was a Nottinghamshire man, Francis, Lord Lovel.

On 4th June 1487 Lincoln's army landed in Lancashire and marched to York. Not receiving the help they had expected they turned south and came through Sherwood Forest, intent upon seizing Newark.

Henry had begun to muster his troops in the Midlands, around Kenilworth. When he heard news that his enemy had landed he immediately sent his men to Nottingham in order to prevent the enemy from crossing the Trent, thus stopping them marching towards the south. In Nottingham he was to receive 6,000 more troops.

The king's troops camped in Bunny Woods on 12th June and the next day his advance guards were at Nottingham. The main portion camped in a bean field some three miles from the town, some say at Holme Pierrepont and others plump for Clifton. The following night the royal army bivouacked in the meadows below Nottingham, beneath the Castle Rock and in the fields stretching towards Lenton.

It was Lincoln's intention that his army should cross the Trent close to Nottingham and on Friday 15th June he arrived at Fiskerton Ferry. It was probably easy to cross the river at that time of the year as the water would have been low. His troops camped on the high ground near to the

18

villages of East Stoke and Elston. The king's troops were alerted and spent the night at Radcliffe-on-Trent.

Henry VII considered Saturdays to be his lucky day, and early on 16th June, his 'day of good fortune', he heard two masses by his chaplains. The trumpets sounded his men to arms and, accompanied by six good men of Radcliffe who showed him the way, his advance guard arrived by nine o'clock that morning at East Stoke.

This party met with Lincoln's main force, drawn up to stop their way between East Stoke and Elston. Historians believe that the Yorkist left wing was placed on the high ground between the Fosse and the village of Elston and their line ran westwards from there, across the highway and over Stoke fields to where the land dropped steeply down to the Trent valley.

Lincoln is thought to have attacked as soon as the king's forward column appeared, who bore the brunt of the struggle. The battle was 'stubborn, fierce and bloody'. After a great struggle in the open fields surrounding the two villages, Henry's men eventually gained the advantage. The remains of Lincoln's army tried to escape down the steep narrow track over Stoke Marshes which led to Fiskerton Ferry. Now they were an easy prey for the king's men, who slaughtered them in this gulley which is now known as 'Red Gutter', as it once flowed with the enemy's blood. This hollow, which is across the fields below Stoke Hall, is composed of red marl, hence its similarity with the colour of blood.

The enemy is estimated to have lost some 4,000 men, and the king's forces some 1,000 less in what was the bloodiest battle ever fought on Nottinghamshire soil.

The outcome confirmed the victory of Bosworth. Never again was the House of York to challenge the Tudor throne. This was the end of the terrible wars between rival families which had bedevilled the country for so long.

Symonds, the priest who had promoted Lambert Simnel,

was cast into a dungeon and no more was heard of him. Simnel's life was spared. He was taken prisoner on the field and later pardoned and made a scullion in the king's kitchen.

In addition to the 'Red Gutter', there is another reminder of the last of the Wars of the Roses. If you turn off the Fosse (now the A446) and head towards Elston, a few hundred yards down the road on the left hand side you will see a little spring, known by the locals as 'Willy Rungle'. It never freezes over, nor does it run dry. Elderly people will tell you how they always had a drink when they passed by in their younger days. Housewives used to draw water from the spring for domestic use.

However, the spring has a legend, for it is said that during the battle of East Stoke a dying soldier came to that point and was comforted by a villager. The soldier said, 'If I die and go to Paradise, a perennial spring will break forth in this place' and that was the origin of what much later was to become 'Willy Rungle'. Its clear water is a silent reminder of the death of some 7,000 men and the start of a new epoch.

Footpads
and
Highwaymen

TRAVELLING about the country in modern times can often be a frustrating experience, but spare a thought for the travellers of yesteryear who frequently had to contend with footpads and highwaymen.

Coaches bearing such wonderful names as the Nottingham Flying Machine and the True Briton were often under attack, as happened on 18th July 1764, when a coach was stopped by two highwaymen, who demanded money or the lives of its passengers. The guard whipped up his horses who shot off like greased lightning. The villains discharged their guns and the coach guard was badly wounded. He later died.

Many of these villains lurked in secluded places along the muddy cart-rucked ways and the better turnpike roads, waiting to relieve people of their goods and money. Indeed a highway robbery was almost to be expected when travelling any distance. Many people were reluctant to use the roads in the dark and delivering the mail was one of the most hazardous jobs after soldiering.

Looking through the Nottingham Date Book from 1750–1850, one is aware of the hazards of the high roads and byroads in the county. Horsedrawn conveyances were beyond the pockets of most folk, who had to walk long

distances regardless of the weather. It was not unknown for people from Nottinghamshire to walk to London and back, all the time dreading robbers, and still more dreading the cost of food and lodging at public houses. Dick Turpin had been active in the county and people such as Thomas Wilcox, alias 'Sawley Tom', and George Brown, alias 'Bounds', had swung for their crimes.

Joseph Corden must have known of the risks as he was returning from Nottingham on 7th March 1827. He had nearly reached his home at six o'clock in the evening when a footpad crept from behind him and dealt him four cruel blows on the head. The victim described his ordeal to the court at his attacker's trial on 2nd April of that year.

He said that when he regained consciousness he remembered a man standing over him, ripping open his coat and waistcoat in search of valuables. This man continued to strike Corden who fought him as best he could. The assailant shouted, 'D--n your eyes, if you don't give me your money, I'll kill you!'

Fearing for his life the old man gave the robber all his money, which amounted to two sovereigns, a half-crown piece and some shillings and sixpences. He did not notice that his watch was missing until later.

As soon as his assailant was on the run, he told the court, he had shouted 'murder' and in less than half a minute a passerby called Grocock had captured the miscreant, a man called William Wells, and returned him to the scene of the assault.

Corden had then accused Wells of the crime, but the latter denied all knowledge, saying that the man he really wanted was last seen running up Basford Lane. Corden remained convinced that the right man had been standing in front of him at Basford and was now standing in front of him in the court.

John Grocock of Basford told the court that he was returning home and saw the prisoner robbing Mr Corden, whom he then heard crying, 'Oh dear, oh dear, I am

robbed!' He saw Wells run up Basford Lane, caught him and enquired what he had been doing. Wells replied, 'Nothing.' Grocock in turn accused the man of attack and robbery, but was told the same story as that given to the victim — that the real thief was running up Basford Lane. Then the witness heard the prisoner throw something towards the hedge and a later search unearthed Mr Corden's watch, a small knife, a two-bladed penknife with one blade opened and a stout stick which was broken at one end. Wells was taken to the police that very night.

It did not take the jury long to pronounce Wells guilty as charged and the judge sentenced him to death, which was to take place on the following Tuesday.

William Wells was not a local man but had been born at Peterborough where he worked as a farm labourer. He had managed to save up a little money and started huckstering vegetables which he supplied to the barracks at Norman Cross near Peterborough, which housed the French prisoners of war.

He later married a respectable girl but took to gambling, which, as was the case with so many people, became his downfall. Then he set his sights on crooked horse-dealing and it is assumed it was around that time that he added spice to his life and money in his pocket through highway robbery.

During his trial Wells gave the appearance of being very cool and unflustered. Despite the terrible sentence dealt him on the Friday, he did not lose his appetite and ate heartily whilst he awaited his death. On the following Tuesday the execution was deferred, but no hopes of saving his life were expected. Wells became very contrite and took comfort from his spiritual instructors, not knowing if he were to die or be saved.

On the Saturday he was informed that his execution was fixed for the following Monday and again he received the information calmly. He counted the hours until the cart arrived to take him to the scaffold, where he was attended

by three ministers who prayed with him for some time. Then he was placed upon the plank and joined the countless other criminals who had met their Maker from Gallows Hill, Nottingham. This terrible place was on the Mansfield Road, close to where the church cemetery now is. The footpad William Wells was the last person to be hanged there.

The Wrestling Baronet

THE village of Bunny was once famous for its annual wrestling match, which was established in 1712 by Sir Thomas Parkyns, Bart, of Bunny Hall.

Sir Thomas, who has been described as 'one of the most endearing eccentrics of the 18th century', was a man of diverse talents, being a lawyer, classical scholar, amateur architect, mathematician, squire and benefactor of Bunny and its neighbouring village Bradmore. He was the author of a book entitled *The Cornish Hug Wrestler* and designed and built many of the farmhouses in the district, some of which are still standing. In between all this he was a magistrate, and pointed out that the County Hall was in an unsafe condition. He was proved right during a crowded meeting in 1724 when the floor gave way and people fell through into the cellars.

Perhaps his most famous project was the wall he designed around Bunny Hall, which is built on a series of arches. He was also responsible for the design and erection of the school and almshouses at a personal cost of £400.

However, it was his love of wrestling which earned him the nickname 'The Wrestling Baronet'. At one time wrestling was a favourite sport in Nottinghamshire and like

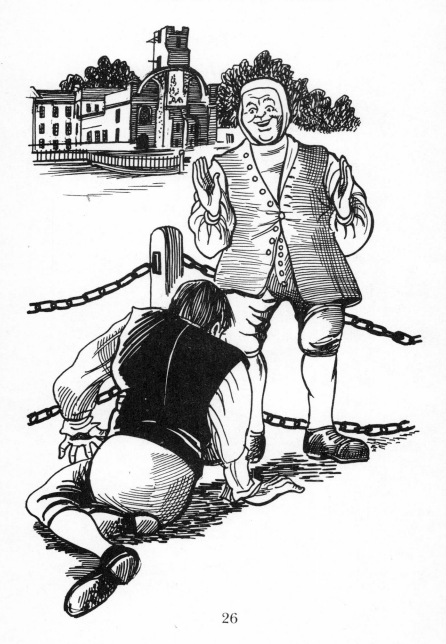

today's cricket and football teams, there were inter-village matches which led to county contests.

From the start the Bunny event was extremely popular. The large, strong men would wrestle for the first prize of a gold-laced hat, value 22 shillings, and three shillings for the second best competitor. The wrestling was regulated by rules laid down by Sir Thomas who usually competed himself, along with his coachman and footman, who sometimes defeated him. The ring was permanent and during matches a chain was placed around its posted perimeter.

The park keeper used to take down the names of the competitors on separate slips of paper, and after shaking them up in a bag, he would draw two names out, who were immediately brought out to fight and the loser would have his ticket torn up. The winner's ticket was placed in another bag, for the next leg of the contest and so on until the match was won.

Sir Thomas died in 1741, aged 78 years. His penchant for wrestling is shown in his monument in Bunny church. It is divided in two sections. The one on the left contains the statue of the baronet in a wrestling attitude, and is said to bear a very strong resemblance to the life model, even to his wrestling cap and jacket which he wore when practising. Above the head of the statue is the motto 'Artificis status ipse fuit' which translates as 'This was the position of a wrestler'. In the lower part of the second right-hand section, the sporting baronet, still dressed as a wrestler, lies thrown at the feet of the Grim Reaper who is disguised as a cherub.

Like so many good things, it was the very appeal of the Bunny wrestling match which became its downfall. Over the years the event caused the 'idle and vicious of both sexes to congregate in multitudes, in a generally quiet village' and in 1811 it was stopped by Lord Rancliffe, the grandson of Sir Thomas. A man named Butler from Hucknall Torkard was the last winner of a prize.

The Shepherd's Race

THE maze known as the Shepherd's Race, or Robin Hood's Race, was cut on the top of a hill close to St Ann's Well and near to the chapel of St Ann at Sneinton Common. It was ploughed up after the Lordship of Sneinton was enclosed by an Act of Parliament in 1795.

These winding labyrinths were once a common feature throughout Britain. Many of the ecclesiastic ones were cut in the Middle Ages. For some curious reason mazes are enjoying a remarkable resurgence. There are now more than 100 in this country, compared with only about 40 a few years ago.

The Shepherd's Race is estimated to have had a diameter of 21 yards and the extreme distance between each projection was some 34 yards. Its winding path was about 536 yards long. Nobody can say for sure when it was built or by whom, but it was an unusual shape, being circular and with four horseshoe shapes forming a 'square' maze.

It is believed to have been cut out of the turf after the Roman period and certainly before the Reformation, after which period many rural mazes were converted into recreation attractions. Shakespeare refers to this in his *Midsummer Night's Dream*, Act II, Scene 2:

> 'The nine men's morris is fill'd up with mud;
> And the quaint mazes in the wanton green,
> For lack of tread are undistinguishable.'

The Shepherd's Race was lucky to have survived Cromwell's rule when many mazes and labyrinths were destroyed, being deemed to have pagan qualities. This Nottingham maze (and there was another square-shaped one at Clifton) was cut out of turf and it has been suggested that it could have had ecclesiastical origins. Maybe the monks at St Ann's chapel had it cut as a means of recreation, or perhaps it was a medium for performing penance for sins of omission and commission in general. This was quite a common function of mazes, the penitents being ordered to follow out all the winding pathways on their hands and knees, repeating so many prayers at fixed stations. Another theory is that it was cut by shepherds, hence its name.

However, the Shepherd's Race was well known for children and young lovers racing through its winding paths. Bradfield in *Pictures of the Past* (1864) gives a charming account of people amusing themselves at 'Sentan's Wells':

> 'Some run the "Shepherd's Race" — a rut
> Within a grass-plot deeply cut
> And wide enough to tread —
> A maze of path, of old designed
> To tire the feet, perplex the mind,
> Yet pleasure heart and head;
> 'Tis not unlike this life we spend,
> And where you start from, there you end.'

Sadly it was ploughed up on 27th February 1797. Later a facsimile was cut in the grounds of Poynters Tea Garden which stood on Blue Bell Hill, overlooking the valley of St Ann's Well and not far removed from the original 'Race'.

This authentic miniature was shaped by box hedging, and the paths were narrow and covered with Beeston gravel, which made running impossible. The Poynters had a half-clipped standard poodle which had been trained to run the maze for a penny. Being an untrustworthy dog he

often took short cuts, yet always demanded payment from his onlookers. He would rush off to his mistress with his coin in his mouth, which he exchanged for a titbit. The Poynters' smart poodle was an added attraction to the tea garden.

However, the model could never have offered the same fun as the real thing, as described by the local historian, Blackner, in the 19th century, who lamented its destruction:

'A spot of earth, comprehending about 324 square yards (only about the 15th part of an acre) sanctified by the lapse of centuries as a place of rustic sport, by the curiosity of its shape and by the magic raptures which the sight of it awakened in our fancies of the existence of happier times, could not escape the hand of avarice which breaks down the fences of our comfort — the mounds of our felicity — and destroys the reverence of custom, if an object of gain or of ambition presents itself to view.

'Here the youth of Nottingham were wont to give felicity to the circulation of their blood; strength to their limbs, and elasticity to their joints, but callous-hearted avarice has robbed them of the spot.'

The Bramley Apple

WHAT'S in a name? Quite a lot, once it has been established. If Mr Herbert had made famous the usefulness of meat or other fillings placed between two pieces of bread before the fourth Earl of Sandwich, we would be eating cheese and pickle herberts! There would be no wellington boots, without the Duke of Wellington and no bowler hats without Mr Bowler the hat maker. What is more we would not be eating Bramley apples without Mrs Brailsford's son-in-law, Matthew Bramley.

It was in the 1820s that Mary Ann Brailsford planted a few apple pips in her cottage garden at Church Street, Easthorpe, Southwell, and quite by accident produced the first tree to bear these large shining green apples which have become one of the favourites of British cooks.

However it was her son-in-law, Mr Matthew Bramley, who inherited the cottage and lived to see the tree flourish and produce heavy crops of fruit which he gave to his friends and neighbours.

In 1856 Mr Henry Merryweather, the son of the founder of the Southwell Nursery, met someone carrying a basket full of this fine fruit. Being unable to identify the variety he asked where the apples came from and was told about Mr Bramley's superb tree. The nurseryman called at the cottage and was given permission to take grafts from the tree. It was from these grafts that Mr Merryweather

produced the first of the Bramley seedling apples, named after Matthew Bramley, which soon became firm favourites for all forms of sweet and savoury cooking.

Mrs Brailsford's tree was planted in what is now 73 Church Street, and recently a parcel of land containing the tree was conveyed to the adjoining property, No 75. It is a good-shaped tree which continues to produce a fine crop each year and its cuttings remain viable. The tree attracts many visitors to this private garden.

Thanks to science the old tree has now been perpetuated by cloning, undertaken by the botany department of Nottingham University. In March 1990 the three ft cloned tree was planted by Sir Gordon Hobday, the Lord Lieutenant of Nottinghamshire at H. Merryweather and Sons' garden centre at Southwell. Cloning gives a much closer reproduction than can be achieved by growing from a seed or grafting.

The elderly tree has not only had to withstand age and the threat of disease. Its progeny has had to brace up to attack from the Common Market. Apparently decent-sized cooking apples are not grown in Europe as they need the wet and warm conditions of a typical English summer. The EEC categorized Bramleys as a 'low rate dessert apple'. Mr Henry Merryweather's great-grand daughter, Mrs Celia Stevens, was one of those who led the successful campaign to gain recognition for the Bramley apple in Europe.

Robin Hood

DID Robin Hood ever exist? Was he the Earl of Huntingdon, or merely a common outlaw. No matter what his origins, Robin Hood is inextricably connected with Nottinghamshire and with Sherwood Forest.

Some historians have suggested that this outlaw's supposed activities may have taken place in the reign of Henry III (1216–1272). It could be argued that if Robin Hood had existed there would have been some documentary evidence of his activities in the court records of that time, which is not the case. However, in later years his name became a popular alias for a number of criminals over a long time span. For outlaws did plague travellers through Sherwood Forest during the Middle Ages and use its secret places as their hideaway. They did hunt the king's deer, and the Sheriffs of Nottingham did terrorise the peasant farmers.

The little church at Edwinstone in the heart of Sherwood Forest is the reputed setting for the marriage between Robin and Marian, but as the latter character was not introduced into the tales until the 16th century this seems doubtful. Blidworth is the legendary birthplace of Robin's bride, which for the same reason has to remain suspect, and Will Scarlet, one of Robin's Merry Men is thought to be buried in Blidworth churchyard.

Locksley in Yorkshire and Hathersage in Derbyshire both claim to be the burial place of Robin Hood, the latter town also being the home of Little John, who was Robin's

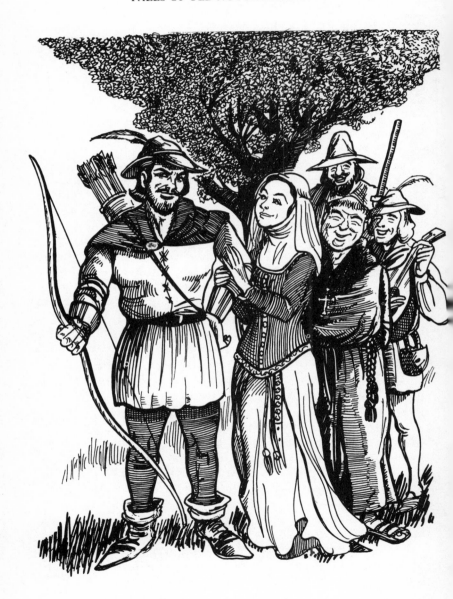

second in command. The putative grave slab of this huge man now stands in the porch of the local church. In 1652 it was recorded that Little John's hat, bow, arrows and quiver were kept in the local church. They were removed in 1729 and the bow now resides in Scotland. Locksley is also the reputed birthplace of Robin.

The original tales of Robin and his Merry Men came from medieval ballads which were not sung but recited. These early sources were not documented and were consequently subject to variations and revision during their oral transmission. Onwards from that period some 38 ballads were composed.

One of the earliest manuscripts is entitled *Robyn Hod in Scherewod Stod* and Sherwood Forest has the closest associations with the man who robbed the rich to give to the poor. This is where the Major Oak still stands, its ancient branches propped and banded against age and decay. Seven hundred years ago the outlaws were said to have gathered under its sprightly form, dressed in their Lincoln green. It was in another large oak called Robin Hood's Larder that they hung their contraband venison. This tree has now succumbed to old age, as has the Parliament Oak or Trysting Tree under which Robin assembled his 'faithful commons'. Unfortunately, despite their romantic links, these three trees were not even saplings in the 13th century.

The longest and most famous tale, *A Gest of Robyn Hode*, is also thought to be the earliest written source, first published around 1510 although the spoken ballads date from before the 13th century. It was in the 16th century that Robin Hood sometimes replaced the May King and presided over the maypoles, Morris dancers and archery contests held at this festival which marked the first day of summer. The Robin Hood play formed part of the entertainment, which dealt with many of his adventures, and Maid Marian was first mentioned at that time. She took the place of Matilda fitz Walter, who in tradition from the

14th century had been the subject of the lecherous King John's attentions.

One of the first Robin Hood plays to be absorbed into the May games was that based upon the ballad *Robin Hood and the Curtal Friar*, being a friar who wore a short cloak. This tells the story of Friar Tuck and Robin's first meeting, which was on the bridge at Fountain Dale, Nottinghamshire, the village being the reputed birth and burial place of this military monk.

It was Joseph Ritson who made the first comprehensive set of ballads one century later and gave emphasis to Robin's anti-establishment activities. He wrote of this outlaw's life in Sherwood Forest: 'In these forests, and with this company, he for many years reigned like an independent sovereign; at perpetual war with the King of England and all his subjects, with the exception however of the poor and the needy, or such as were desolate and oppressed, or stood in need of his protection.'

In the 19th century Robin Hood became romanticised into our now accustomed hero when his adventures were absorbed into children's literature. Pierce Egan wrote *Robin Hood and Little John* in 1840 and many authors followed suit. The 20th century gave further emphasis to romance and adventure in literature and popular films starring such screen idols as the swashbuckling Errol Flynn and Richard Green.

Robin Hood has travelled a long way over almost 800 years. Never portrayed as a villainous highwayman or footpad, he evolved as a bright young blade, cleanly dressed in clothes of Lincoln green, the defender of the poor and justice. Robin never molested a hind at the plough or a thresher in his barn, neither did he take liberties with the fairer sex. He spent much time relieving maidens in distress, whilst widows and fatherless children looked to him for care. This outlaw was the champion of old women, the sick and disadvantaged. He became a May Day tradition, a romantic figure in print and then a silver

screen heart throb. His exploits delighted audiences both in verse and song. Irrespective of the medium, Robin Hood must surely be one of the most famous and well loved of all our English folk heroes.

The Fools
From Gotham

MANY people are familiar with the name Gotham (which in Nottinghamshire is pronounced as 'Got-ham'), from the nursery rhyme:

> 'Three wise men of Gotham
> Went to sea in a bowl;
> And if the bowl had been stronger,
> My song would have been longer.'

However, there are many more tales of fantasy connected with this village and it begins with the legend that when King John was making a trip to Nottingham Castle he had to pass through the village of Gotham. In those days it was believed that wherever the king walked it was from that day a royal highway, with public rights of way.

In order to prevent the loss of cattle grazing land the Gothamites conceived a cunning plan to dissuade the king from passing through their village. When the monarch's advance party came to their village they would feign lunacy and play at being harmless fools and this should be sufficient to keep the royal party away.

When the king's scouts came upon Gotham, to their amazement they found several of the villagers trying to drown an eel in a pond. Others were trying to put a fence around a cuckoo, saying that by trapping the bird it would

be springtime all the year round. Cuckoo Bush Mound can still be found at Gotham. The king's men then saw some men tumbling cheeses down a hill, saying they were trying to roll them into Nottingham Market Place. Lunacy was abroad. The cunning plan worked, for the king circumnavigated Gotham and the grazing rights were retained.

Dr Andrew Borde, an eminent physician at the time of Henry VIII, is reputed to have written the first book about the fools (or wise men) of Gotham. This work is entitled *Certaine Merry Tales of the Mad Men of Gotham* and is said to be lodged in the Bodleian Library at Oxford.

There is the tale of a man who rode to market with two bushels of wheat, and to ensure that his horse did not have to carry the burden on its back, he carried it on his own and sat astride the horse.

Then there was the smith who had a wasps' nest in the thatch roof over his smithy. His customers complained of the wasps and so the smith got a red hot poker and shoved it in the middle of the nest. His thatch went up in flames and he replied proudly, 'I told thee I would fire them forth of their nest.'

A Gotham woman was given instructions by her husband to wet the meal before giving it to the pigs. She therefore threw the meal into the well and the pigs after it!

Another story tells of difficulties at a Gotham wedding. The priest who was marrying the happy couple said to the groom, 'Say after me.' The fool said 'After me.'

The priest said, 'Say not after me such words, but say after me, as I will tell thee.' The fellow said, 'Say not after me such words, but say after me, as I will tell thee.' After more of this the priest could not tell what to say, but said, 'What shall I do with this fool?' The fellow said, 'What shall I do with this fool?' 'Farewell,' said the priest. 'I will not marry thee.' 'Farewell,' said the fellow, 'I will not marry thee.' The priest departed but eventually the fool was married by a more tolerant man of God.

There are 20 tales in Borde's book, many of which have plots similar to those found in traditional pantomime. The stories have been reprinted many times and there are naturally several variations, but they all chart the harmless foolery of the people from Gotham.

Ned Ludd

THE early 19th century framework knitters of Nottinghamshire made stockings on machines which had been invented in the reign of Queen Elizabeth I. In 1589 William Lee, a native of Calverton, Nottinghamshire, devised the stocking-frame, which revolutionised the hosiery trade in the Midlands. A popular romantic story says this came about because he was fed up with the way in which his lover paid more attention to her knitting than to himself. Producing a machine for knitting silk stockings would mean she would have more time for courting.

Nine years later he presented a pair of silk stockings, made on his new, improved knitting frame, to Queen Elizabeth I in the hope that she would endorse the machine. However, neither she nor her successor, James I, encouraged Lee as they thought there would be too much trouble from redundant hand knitters. The inventor emigrated to France and set up his machines in Rouen, where he died in 1610.

His brother James returned to Nottinghamshire where he started a partnership with a mill owner using the machinery invented by brother William. In 1614 there were just two master hosiers making machine-knitted stockings in Nottingham, but by the end of that century the stocking trade was booming, with 60 per cent being made from silk.

Stockings were manufactured both in factories and by cottage workers operating their own frames. Therefore it

was a trade conducted in both towns and villages. Some outworkers managed to buy their machines, others were the property of merchants who rented them out at a weekly rent. Other people rented weekly space in a 'shop of frames' containing eight or ten frames. However, although some worked all hours of the day and most of the night, it was becoming harder to earn a decent living.

In 1778 the framework knitters applied to Parliament to raise the rate of wages, to lower the charge for frame-rent and to prevent abuses and frauds in the trade. They were an independent class of men, proud of their craft and determined to claim their rights as they saw them. Their petition was presented by Daniel Parker Coke, MP for Derby. It stated that they had served regular apprenticeships and had always employed themselves in making stockings, mitts and gloves on the stocking-frame, of silk, cotton, thread and worsted, but despite their hard work they were incapable of providing the basic necessities of life for their families. This was not only on account of their small wages, but the paying of frame-rent and other costs needed to keep the machines in working order.

The merchant-hosiers, who had formed themselves into an association, appointed Mr Samuel Turner, an attorney, as their agent and secretary. However, in fear of retribution from their workers, the hosiers did not speak out against them. Finding it necessary to produce some kind of defence against the petition, Turner induced two master stocking-makers, Henry Cox and James Thorpe, to give evidence, doubtless hoping this would persuade the hosiers to give them some backing.

The committee of the House, aware of the position of the hosiers, dispensed with the counter evidence, and made a report upon which the bill was founded. On 25th February the House voted 27 for its admission and 52 against.

The defeated petitioners were furious and poured their wrath upon Cox, Thorpe and 'Lawyer Turner'. Cox had his windows smashed, his family terrified and his life

42

threatened. The other two had stones thrown through their bedroom windows whilst they were sleeping. The hosiers put up a reward of ten guineas for the discovery of the offenders. They were never found.

For the rest of that year the frameworkers acquired more followers, and large subscriptions were raised. A further petition was presented to Parliament in 1779. A committee was again appointed to enquire into its merits. The evidence attested the low rates of wages, and the high rate of frame-rent. A master stocking-maker proved that his workmen's clear earnings did not average seven shillings per week.

On behalf of the hosiers, Mr Need, a wealthy factory owner, in partnership with Richard Arkwright, the inventor of the spinning frame, stated in evidence that the workmen were sufficiently remunerated. Such were the advantages of the manufacture, they said, the more children a workman had, the better was his condition of life. A reduction in frame-rent would prove ruinous to the manufacture, by discouraging people from buying their frames. Furthermore, they threatened, if a bill was passed to restrict their business, the hosiers would sell their frames and retire from the trade as they should be undersold by the French.

They also produced evidence from a lad named Wilkinson, which lent great weight to their evidence. This youth, who was henceforth called 'the miraculous boy', swore that he could earn 20 shillings a week with great ease.

In May, leave to carry the bill was granted with just one dissenter. One MP speaking in its favour spoke as one 'moistened and saturated with the tears of the poor and their distressed families.' The Nottinghamshire workers were elated and throughout the county subscription lists were opened to raise money to carry the bill through its future stages. Tradesmen canvassed their customers, most public houses had their own list and almost every street and village had its own collector. The second reading, a short

time after, was carried by a majority of one — 24 against 23, but on the third reading it was lost by a majority of 57 to 18.

News of the defeat reached Nottingham on 10th June, which coincided with a great holiday among the Jacobites, who wore white roses in honour of the Pretender's birthday.

In a very short time the town was in a ferment. The frameworkers rallied in the market place and at ten o'clock at night their anger burst into violence. They rushed into Parliament Street where they broke every pane of glass in the house of Mr James, a large hosiery manufacturer.

Then they proceeded to deliver the same treatment to other wealthy manufacturers, including the hated Mr Need, who with Richard Arkwright had spoken in favour of the hosiers earlier that year. Mr Wilkinson, who had produced 'the miraculous boy', had his windows broken and furniture smashed.

The magistrates had not anticipated any violence and they, in the company of the officers of the Royal Horse Guards, were attending a ball at the race stand. Upon the bugle sounding to arms at midnight, the officers mounted and rode into the market place dressed in their 'ball dresses' where they remained until daybreak.

The exasperated people resumed their work the following day, the magistrates read the Riot Act, and the crowd dispersed, to do its work elsewhere. Messrs Need and Arkwright's mills had their windows broken, the soldiers arrived too late and the men managed to smash up the home of 'Lawyer Turner' with ease.

The soldiers formed themselves into patrols to thwart the rioters, but eventually returned wearily to their quarters. No sooner had they dismounted and were feeding their horses than the house of a hosier called Churchill, who lived at Wheeler Gate, became the centre of an attack so violent that he thought it better to leave town rather than try to repair it.

Later that day the men tried to fire Need's mill, but the

soldiers were waiting for them. The frameworkers decided to leave some men at the mill, to engage the soldiers' attention, whilst others made a quick march of four miles to Arnold where they attacked Mr Need's country house, broke up his furniture, smashed up his staircase and brought the roof down. Whilst this was going on at Arnold, another mob broke into his town coach house where they destroyed his carriage and harness.

'Mr Need having been sufficiently punished,' says the *Nottingham Journal*, 'they all ran away, to sleep easy and happy.'

The next day saw similar disturbances but the next, being the Sabbath, was quiet. The following Monday the stockingmakers from the villages poured into Nottingham and enlarged mobs became even more violent. Frames were taken out and smashed in public, the shops of hosiers and middle men were violated. The town was in a feverish state. The Riot Act was again read, all business suspended and shops closed.

A report of the events states, 'In the height of the storm, oil was poured upon the troubled waters in a way which shows how powerfully an appeal to reason will sometimes triumph over the passions of a mob. About eight in the evening, an individual harangued the multitude, in the Market Place, and after exhorting them to behave more like citizens, assured them that the hosiers would hold a three counties meeting on the morrow, with a view to redress their grievances. Tranquillity was at once restored, two men who had been taken prisoner by the soldiers were released, the people went peacefully to their homes, and the soldiers to their quarters, as though nothing had happened.'

Unfortunately on 21st June the hosiers failed to meet the frameworkers' demands and violence resumed. The next day 300 of Mr Need's machines were destroyed at Arnold and Wilkinson's house was burned down.

The mayor issued a proclamation in which he stated that

'Further lenity would be a crime, and that the vigilance of justice should be exerted in its utmost severity.' The hosiers advertised that they were now one compact body, which would punish offenders and encourage those who were peaceably inclined. They later issued a further conciliatory advertisement, in which they stated they 'would remove every oppression, providing a cessation of the riot took place.' Rioting died down and the participants received their judicial punishment.

Over the years outbreaks of dissension continued on an ad hoc basis, but by 1811 it was clear that the outbreaks were becoming more organised and deliberate. The participants were no longer shouting mobs but trained gangs led by masked men following almost military principles. The name of the mythical 'General Ludd', or 'Ned Ludd' was signed on the bottom of inflammatory posters and handbills.

It is said that a Ned Ludd did actually exist. He was a simpleton with a ready temper who lived in a Nottinghamshire village and was tormented by the jibes of the local children. One day at the turn of the 19th century he chased a small boy who had been teasing him but the boy managed to escape. Ludd was so cross that he smashed up two knitting frames to vent his anger. Thereafter Ned was blamed for all the machinery destroyed in his area and became a useful scapegoat who quickly turned into a legend.

The first official Luddite violence is said to have been mustered by the Nottinghamshire frameworkers and took place in Nottingham Market Place on 11th March 1811, which led to the destruction of 60 frames.

Luddism quickly spread to many industrialised parts of England where the poverty stricken workers went 'Ludding'.

The name 'Ned Ludd' became synonymous with that of the bogeyman in many comfortable households. Their children were threatened with a visit from Ludd as an

46

ultimate form of punishment. It was said that men who disregarded an order from 'General Ludd' risked death. The children from poor families were taught to hold him in great respect. Many followers of Ludd were imprisoned and executed but it did not deter their campaign to wage war on the bad conditions and poor wages which were the lot of the stockingmakers and cloth workers.

The 'Followers of Ned Ludd' continued their work in Nottinghamshire through to 1816, when the last reported incident was on 2nd November at Bulwell.

The final Luddite attack appears to have been in Leicestershire in 1817 when a large factory at Loughborough was attacked by a group of men armed with blunderbusses. Afterwards the last of the Luddite heroes was executed. The world had changed and the machine had come to stay.

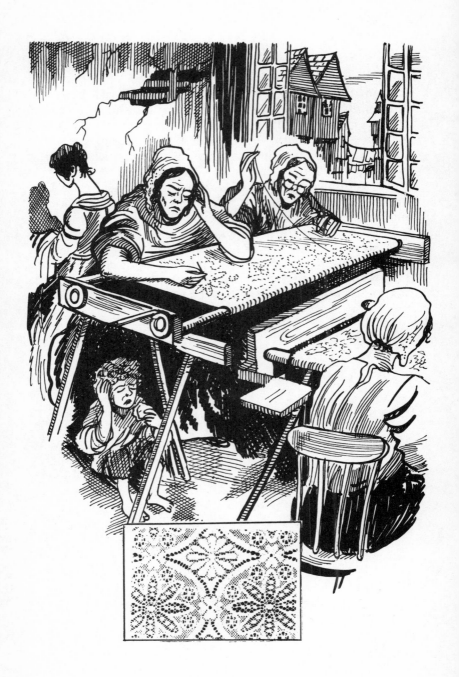

Twist Fever

BEFORE the invention of the bobbin net machine, most lace in this country had been handmade on little pillows and known as Brussels point or 'pillow lace'. This was a time consuming and intricate task using a pattern pricked out by pins on parchment which was secured to the pillow or cushion. The thread was twisted into pattern by using bone bobbins, identified by coloured beads threaded into a circle through their head. Many of these bobbins bear messages of love or the owner's names, pricked out and coloured along the shaft — 'Love Come A Gain', 'Mary', 'Sarah'. They all bear a memory and are now highly collectable.

In 1809, Mr John Heathcote of Loughborough obtained letters patent for 14 years' protection of his invention of the bobbin net machine. During this period he and his partner, Mr Charles Lacey, levied a heavy tax upon copies of this machine. When the patent expired in March 1823, 'Speculation the most extensive and ruinous set in, and capitalists of every grade anxiously embarked their money in the bobbin net vortex.' The producers of the material manufactured on the new machines could turn out quantities of the stuff at a high retail price. It is said that soon after Heathcote's invention lace was sold at five guineas per yard. Twenty years later it was making 18 pence a yard. In the early days the machines gave their investors a tremendous return on their capital outlay.

Besides the usual business entrepreneurs, butchers,

bakers, bankers, clergymen, farmers, publicans, lawyers, in fact any one with a little money to spare or the power to borrow, invested in the lace bobbin machine which was to turn Nottinghamshire into the premier lace making county in England. Many people from outside the area became 'Lace Adventurers'. The lace manufacturers themselves appear to have owned no more than one third of the total number of machines.

The lace industry was not confined to Nottingham, but factories were also established in outlying areas such as Basford, Arnold, Beeston and Lenton. Cottage workers operated from their homes in the villages surrounding these towns.

Hundreds of mechanics, tempted by better wages, poured in from Sheffield, Birmingham, Manchester and other places. Money circulated freely and much of Nottinghamshire rode high on gain. People were in the first throes of 'Twist Fever'.

While the fever lasted the machine makers had the greatest share in the prosperity. Many could not meet the demand for their goods. The setters-up were the best paid workers. Their charge for adjusting a six quarter levers machine was £20 2s and took from two to three weeks to complete.

During the excitement the number of master smiths in the town and neighbourhood was more than trebled. Stables, kitchens, cellars and the most unlikely places were converted into smiths' or bobbin and carriage makers' shops.

With so many people flocking into the area to work in this 'golden industry', new houses were thrown up at an alarming rate. Rows and rows of back to back housing were crammed into Nottingham by greedy speculators who cared not a jot for the inhabitants' health or convenience. The price of land and materials rose. No sooner was a row of dwellings roofed and glazed than the chimneys were smoking and the rentals commenced.

It is said that the general enquiry was not so much, 'What is the rent?' as 'Will you let me a house?' In one instance a butcher who had been exhibiting a 'wonderful pig' in a common showman's caravan, 'ousted the porkine tenant, and stationing the vehicle in his garden at the back of York Street, actually let it to families as a dwelling place for two shillings and three pence a week.'

By 1825 the demand for lace had peaked and prices were falling, thus lowering the temperature of 'Twist Fever'. The more circumspect of the machine holders began to curtail their operations and gradually sold out. Some of these men had risen from nothing and by retiring in time made considerable fortunes. The majority, however, did not foresee the end of the initial boom and lost much of their investment.

By 1830 many of the Nottinghamshire lace workers had emigrated to France, where wages were rumoured to be some 60 per cent higher than in their home country.

As the market levelled out, so did the wages and conditions of work. Young children over the age of five years worked for perhaps 17 hours a day winding the thread onto machines. They slept on heaps of material thrown into the corners of their place of work. Some children were even kidnapped from the big cities and forced to work in the Nottinghamshire factories. The poor little mites were brought up in an environment of drink and worse and died an early and unnoticed death.

Many women 'lace runners' or embroiderers who worked from their humble homes did so for a mere pittance. Seated at their rented frames for long hours they handfilled with a needle and thread the lace patterns stamped on the plain net, earning about one halfpenny an hour. Others worked for females who rented work houses for their operatives and deducted fees from each woman for the use of the frame room. It was common for the ten women labouring in one room to cook a hash or stew in a

TALES OF OLD NOTTINGHAMSHIRE

corner for a few pence to feed themselves during their stay of up to 17 hours a day.

The women who attended the material after the lace runners' labours were better paid, but their task was even more ruinous to their eyesight. These 'lace menders' had to examine each piece of work and mend, with needle and thread, every defective mesh in the net. They were so skilled that their mending was quite invisible.

A commissioners' report was made on the housing and moral conditions of Nottingham in 1845. The streets of this rapidly filling town were 'generally narrow, unpaved, uneven, ill ventilated, noisome and damp, owing to the absence of sewerage. . . .' The houses 'have no back yards and the privies are in common to the whole court: altogether they present scenes of a deplorable character and of surprising filth and discomfort. The younger members of families are driven into the streets; and thus girls and youths, destitute of adequate house-room, and freed from parental control become accustomed to gross immoralities.'

Over the years the fortunes of the lace industry dipped and then soared to new heights so that by 1890 there were over 500 lace factories in Nottingham alone, employing some 17,000 people. It is said that some 80 yards of lace trimming were needed to complete a large Victorian skirt! In 1911 half the country's lace workers were working in Nottingham.

The high storeyed warehouse buildings which form part of the area in Nottingham known as the Lace Market were built to impress the buyers. This was also where the 'travellers' or lace representatives packed up their huge quantities of samples — sometimes more than 2,000 — and took them to all parts of the world. Only the finishing touches were done in these buildings, the actual production taking place elsewhere.

The industry's decline came from 1920–1926 when lace

lost its fashion appeal and the home market could not compete with cheaper foreign imports. During this period half the companies went bankrupt, but happily the lace industry still plays its part in the economy of Nottinghamshire today.

The Gypsy
and The Lady

A LONG time ago a handsome young gypsy was walking towards Nottingham. When he drew close to the city he saw some large notices and stopped to read them. To his amazement they were advertisements announcing that a young, rich and beautiful widow who loved all that was good and charitable was in need of a well built husband.

Upon reaching the nearest tavern the newcomer asked around for the identity of this lonely but interesting woman. The gypsy was told that she really was a beautiful, rich young widow, who alas had not had much luck with her seven husbands. It was rumoured that these well built chaps all died off like flies after the honeymoon. Nobody could recollect any church burials, but they had probably gone into the family vault.

Yes, she owned a beautiful house, lovely furniture and had a different servant for each day of the week. All she was lacking at the moment was a strong, able bodied young husband. The Nottingham lads looked at the stranger and agreed amongst themselves that he was probably just the fellow she was seeking. They complimented him upon his height and generous yet muscular body. His thick shining hair was just waiting for the caresses of a fine lady! Never had they seen better brown eyes or white teeth in such a handsome face! Look at those muscles — he was as strong as a cart horse and as good as married to her already! Could

he read? Of course he could or else he would not have known about Lady X! They wrote her address on a piece of paper and pushed it into his pocket, bidding him good luck and to remember them when he had pockets filled with gold.

Now the gypsy was poor and in need of a roof over his head. He was tired of wandering about from town to town doing odd jobs and being treated worse than a dog. A rich, good looking widow was just what he needed, but the thought of her seven dead husbands struck a warning note. However, he was made from healthy country stock and could well look after himself and keep the rich woman happy.

The next morning he bathed himself, straightened his clothes, spat on his boots, flexed his muscles and knocked on the door of the grand house. He was received by a maid who took one look at him and enquired if he had come to discuss matters of a delicate nature with her mistress?

He dismissed the boldness of her question, affirmed that he was indeed calling on matters of a personal nature and was duly presented to the widow, who surpassed his wildest dreams. Notwithstanding her fortune she was everything a young man could desire. Her refined beauty and gentle bearing quickly dispersed any doubts concerning her need to advertise for a husband. The rustic stood dumbfounded, gazing at her in anticipation.

The lady smiled at the gypsy boy, looked him up and down with the eye of one who knows what she is looking for, and without more ado announced that he would do very nicely. She suggested, rather vigorously even for a seasoned bride, that they should dispense with a long engagement for she had been without a husband for long enough. In her eyes, she confided, he was absolutely delicious!

A grand wedding was arranged in as short a space as it takes to organise such a splendid event. The couple were married and the now familiar ceremony was tolerated by

her friends and relations, who were intrigued by her choice of eighth husband. After the nuptials there was much roistering and eventually it was time for the newly-weds to retire to their chamber.

All went well until the young man awoke in the night and found his bride was missing. He called out for her, but she did not respond. He hunted all over the great mansion for his beloved, but she was nowhere to be found.

Being used to sleeping rough he was not versed in the ways of the rich. He dismissed the absent bride as being a common custom amongst the gentrified people of Nottinghamshire and so retired to bed and was soon fast asleep. The following morning, his bride was snuggled up close beside him, enquiring if he had slept well. He did not like to say that he had found her missing so he smiled contentedly and said that he had slept like any happy bridegroom.

'My love,' crooned the bride, 'you are so beautiful I could devour you, my big dimpled duckling!'

The same thing happened the next night although she was back beside him in the morning, again enquiring in an adoring manner if he had had an uninterrupted sleep. He replied that his sleep was as sound as that of the dead.

'Sweet gypsy boy,' she whispered, 'I hunger for you!'

On the third night the new husband only pretended to be sleeping and felt his wife slip gently out of bed in her usual manner. With half closed eyes he watched her dress silently and skilfully in the full moonlight. Then she tiptoed across the room, carefully opened the door and was away like a shot.

He followed her at a safe distance, out through the house, into the garden and along a narrow pathway which led to a remote part of the grounds which he had not visited before. The moon was so bright he could see clearly from a safe distance as she approached what looked like mounds. He moved a few steps forward and counted them, one, two, three, four, five, six, seven.

The woman knelt down and started to dig at one of them with her bare hands. He edged a little closer and saw her burrowing as furiously and excitedly as a terrier at a foxhole. The gypsy crept closer still, with all the skills of a master poacher and the cunning of his ancestors, yet his heart was banging like a tin drum.

When he was just a few terrible feet away from his darling wife she stopped clawing at the ground and started to tear at something with her teeth. She let out loud grunts of satisfaction as she pushed more delicacies into her now decidedly unladylike mouth. A few more silent moves and he was able to see that she was gorging herself on meat which smelled far worse than an old paunched rabbit.

She reached in for lumps of the stuff which she swallowed like a beast, occasionally freeing her lips of spittle and earth which she wiped on her silken sleeve. She snarled and drooled over the tough bits and swallowed the tender pieces whole. She was totally happy as she guzzled and belched her way through that atrocious midnight feast.

The bridegroom could stand the sight no longer. He broke cover and pulling himself to his full height demanded to know what she was eating. The bride looked round, stood up and faced him with no hint of shame on her once lovely face, which was now filled with hatred and evil. She grinned nastily as she flung a rock at his skull and screamed out 'I'm eating corpse, you fool, I'm eating husband corpse!'

Old
Sherwood Forest

OLD Sherwood Forest was once much larger than it is
today. In 1300 it was roughly 20 miles in length by
eight wide. At one extremity was Nottingham, at another
Mansfield, whilst Worksop was close to the northern
boundary. The forest contained some 100,000 acres, or
nearly one fifth of the county.

During the winter of 1222 a terrible storm is said to have
swept over England. Trees were overthrown in such huge
numbers that special writs were quickly issued prohibiting
the Sherwood Forest administrators from claiming their
perquisites of fallen boughs or root-fallen trees. Instead
the overthrown timber had to be sold and was accountable
in the forest returns.

Some interesting forest offences came to light when the
Forest Pleas or Eyres, presided over by the king's justices,
were held at Nottingham. These courts were supposed to
be held every seven years but in reality were held at much
longer and fitful intervals. The earliest recorded court was
held in 1251, when the forest was divided into three
keepings or wards, each of which had their own verderers,
foresters and agisters. The latter regulated the pasturage
and the pannage of pigs permitted within that area.

At the Eyre of 1267, several hundred vert offences were
brought before the court for damage to the growing
timber. The most serious was that of the Abbot of Rufford,

who was charged with felling 483 oaks for building material since the last session. However, he successfully mitigated his offences by pleading a charter of Henry II.

It appears that the next Forest Court was not summoned until 1286. During the preceding year there had been a catastrophic outbreak of murrain amongst the deer, both red and fallow, from which 350 had perished.

Special injunctions regarding future administration were laid down on this occasion. It was agreed that any dweller in the forest caught felling a tree was to be summonsed to the next Attachment Court, there to find bail until the next Eyre, and to pay the fine to the verderers. For a second offence he was to be dealt with in the same manner, but for a third offence he was to be placed in Nottingham gaol, 'and there to be kept until delivered by the king or justice of the forest.'

Anyone living outside the forest caught cutting any greenwood was to be placed in prison and dealt with as above for his first two offences. For a third he was also to forfeit his horses and cart, or his oxen and waggon.

It was also laid down that the verderers were to assemble every 40 days, to hold Attachment Courts for vert, venison and other small pleas. Also known as the Forty-Day Court, or the 'Swaynmote', these were held on a regular basis over a very long period and were held at Calverton, Edwinstowe, Linby and Mansfield on successive days of the week.

In 1316 the Archbishop of York's great wood at Blidworth was being administered by the king, as the see was vacant. Edward II ordered the forest keeper to deliver to the sheriff 50 leafless oaks out of that wood, to be used for making charcoal and for boards and trestle tables. Likewise 30 oaks from parts of the forest near the Trent were to be sent to Nottingham Castle for firewood in the king's hall and 30 more for the king's chambers.

Even in woods in private ownership within royal forests, there was no power of felling timber or cutting wood,

except for immediate personal use, without a direct royal warrant.

An interesting use of timber was entered in the Close Rolls towards the end of 1323–24 when an expedition was about to be undertaken into the Duchy of Aquitaine. The Sheriff of Nottingham and his carpenters were instructed to procure as many oaks and other suitable trees out of the forest, as were necessary for the construction of nine springalds and a thousand quarrels. The former were military catapults and the latter arrows with iron heads which these catapults discharged.

The general custom which prevailed in most of England's royal forests concerning their tenants was for them to have the use of wood for the repair or building of their houses, for the construction of hedges and for the purposes of fuel. This was viable throughout Sherwood.

The largest and most substantial beams used in the construction of St Paul's Cathedral were provided by the grand oaks of Sherwood Forest. Papers held at Welbeck Abbey are said to include a letter from the architect, Sir Christopher Wren, dated 4th April 1695, addressed to the steward of the Duke of Newcastle. He states the required dimensions of the 'great Beames' which were to be '47 ft long, 13 inches at the small end, of growing timber, and as near as can be without sap.'

In 1531 Henry VIII appointed a commission to view and certify the number of deer in the forest and parks of Sherwood. The red deer numbered 4,280 and the fallow 1,131. The former ranged through the forest, and 200 were contained in Bestwood Park. The fallow deer were within the four parks of Bestwood, Clipstone, Nottingham and Thorney.

Queen Elizabeth, in 1599, granted the keepership of the forest district of Thorneywood, to the north of Nottingham, to John Stanhope, with licence to hunt, chase and kill the deer, provided he always found a hundred head for the use of the queen. During the Commonwealth

a large number of deer vanished from the forest and in 1661 Charles II had to find a considerable sum of money to import red and fallow deer from Germany for the restocking of both Sherwood and Windsor Forests.

The monarch did his best to revive the forest laws of Sherwood in 1662. The business placed before the new Forest Court was so complicated that although it opened at Mansfield in February 1663 the proceedings were not concluded until 1676. Claims to special privileges were put forward by numerous people including the Archbishop of York, Sir George Savile of Rufford, Lord Byron of Newstead and others who had succeeded to monastic properties sacked by Henry VIII. Scores of minor claimants came from all parts of the forest and its surroundings, pleading privileges which existed in the old days to particular towns and parishes.

In 1708 a strongly worded petition was drawn up at Rufford by representatives of the north of the county, addressed to the Crown. They complained of the almost intolerable burden placed upon landowners by the increasing number of red deer in Sherwood Forest. So many of the woods had been granted or given away by Queen Anne's predecessors there was little shelter for the deer, who were scattered all over the county eating up grass and corn. During times of severe weather their tenants had to sit up all night to scare the beasts away. Their tenants were being terrified by newly appointed keepers who threatened them if they so much as set a little dog on the intruding animals. However, the petition received short shrift as it was argued that to attempt to cut down the number of deer through Parliament would be detracting from the queen's liberties and rights.

Reports presented to the Commissioners of Woods and Forests in 1793 showed that there were then no deer in the forest save in Thorney Woods, of which Lord Chesterfield was keeper. A great many deer were to be found in Birkland and Bilhagh until about 1770, when they were

61

killed off, with the assistance of the local people, by the Dukes of Newcastle and Kingston. In a short time the value of the forest farms increased and the wheat fields no longer needed to be guarded by horns in the daytime and by fires at night.

The forest has changed beyond imagination since its legendary days of Robin Hood. It now shelters an all weather holiday village and tourist centre instead of old style outlaws and bandits. Yet notwithstanding commercial interests, there are still many beautiful places to explore far removed from the crowds.

Cries of
Old Nottingham

THERE are still a few street vendors shouting their wares in the centre of Nottingham, but this is literally a far cry from the days still within memory, when the air was busy with their calls. The surrounding villages and towns also had their share of shouting. Shopping was certainly a different experience in the days of 'Juicy Yemons' and 'Professor' Brown, the 'Swell Quack Doctor'!

Many older readers will probably remember the man shouting 'Coal-e-oh! coal-e-oh!' and people going out to buy their coal which was weighed on large scales from the back of his cart, the gentle horse waiting patiently with its velvet nose stuck in its nosebag.

Then there was the scissors, saws and knives grinder, who walked for miles pushing his cart with its big treadle wheel which drove the smaller grinding wheel.

In the days before mass communication it was common for the *Nottingham Journal* and the *Nottingham Evening News* to print special 'Stop Press' editions, almost hourly, to keep people abreast of important news or some terrible disaster. Well into the night an army of chaps would run around the streets of Nottingham and its neighbouring areas calling, 'Read all about it, read all about it! Such-and-such disaster, read all about it!' and they always had plenty of buyers.

The Rag and Bone Man was always a favourite with children who eagerly awaited his call, 'Rags a' bones, bottles

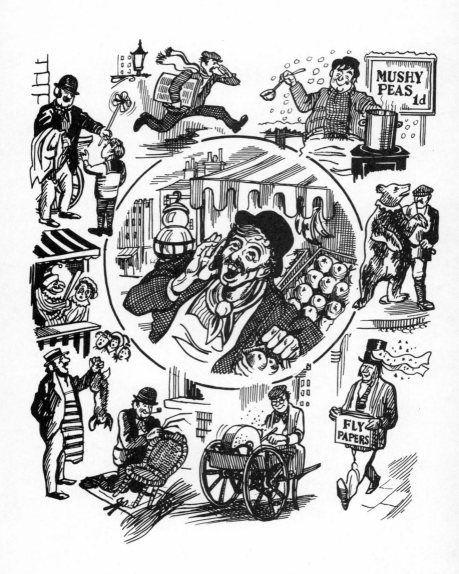

a' jumpers!' as he walked up their street, pushing his cart. He would give them a little gaily coloured paper windmill attached to a stick in return for a few items. If there was a lot of stuff to get rid of then 'mother and father took it out and got a copper.' After the 1930s the children's reward was upgraded to a goldfish which soon died from lack of proper care.

Rabbits were a cheap form of meat, and 'rabbit men' were everywhere, calling out to housewives, 'Do you want to buy a rabbit? I'll sell you one for sixpence. Do you want it skinning? I'll sell you one for a bob!' Then a suitable animal would be selected from his handcart and it was rabbit stew for dinner.

One old man called out 'Buy a-rabbit, cheap a-rabbit' over and over as he stood in the centre of Nottingham with one armful of skinned rabbits and the other armful of unskinned ones.

'Buy a-rabbit, cheap a-rabbit' mingled with 'Now you fish buyers. . . .' This was the cry in the Market Place emanating from the fish stalls, where sometimes on hot Saturday nights the fish spoke for itself. There was old Hack Rowe calling 'Mussels-alive-O!' at the top of his shrill voice and another man in a top hat announcing 'Fine new shrimps, fresh come in!' These calls intermingled with 'Fine oily kippers!' and 'Pyclets!'

One strange man used to walk around the city wearing a top hat decorated with fly papers on which were stuck hundreds of captive insects. He invited people to catch flies his way: 'Catch em' alive, O! All alive!' Little boys were happy when their mothers bought fly papers, which were hung from the ceiling and dripped sweet glue onto the floor on hot days. Not only did the long papers get caught up in unwary adults' hair, they provided hours of fun for certain children who enjoyed watching the winged insects buzzing themselves to eventual death. Sweets and marbles have been known to change hands when making bets on which would die first.

Nothing was more welcome on a cold winter's night than to hear the Hot Pea Man calling 'Hot peas, smoking hot!' A penny would buy a big dollop of mushy peas which came from the old pea can which the trader carried on his arm. Whenever the river Trent was sufficiently frozen for skating, there he was, with his little portable stove, standing on the ice calling 'Hot peas, smoking hot!' with queues of nipped fingers clutching their pennies, anxious for a lovely hot feast in the open air.

His greatest rival must have been the 'penny hot pie man' who carried his pies in a tin which he slung across his back. He too had a makeshift stove on four legs where he kept his pies 'all nice and hot'.

A regular cry on the eastern side of the city came from an old sailor who called out 'Onion nets, a penny each! It's a charity to buy one from a poo-or old sailor!' It was indeed a hard heart who could refuse such a pitiful, and possibly rich, old man.

'Now for yer blue-buttons!' This was not the message of a tailor but another 'old salt' offering mushrooms for sale.

Again within memory there was a very old chimney sweep who used to waken sleeping people at an ungodly hour of the morning by crying out in a voice which belied his age, 'Do yer want yer chimney sweepin?'

Apparently most of the Nottingham chimney sweeps saved their soot for the annual football match which took place between the Sweeps v the Bakers, which used to be played, or rather fought, for the benefit of the hospital. This match was always accompanied by a flour and soot flinging contest.

'Cane chairs to bottom and mend' boomed the chair mender as he walked around the city, carrying an armful of canes and a kneeling mat. He would call out his first two words loudly and let the second word 'swell' and then quicken up his beat on the last four.

The old man who once stood in the Market Place wearing a peaked cap bearing the message 'God is Love'

has long since cried his last invitation to 'Corn salve, a penny a packet!' He was a tall, bent man, who pushed a home made barrow constructed from a soapbox on pram wheels. After making his first announcement he would call out in a softer voice to the women, 'Now then you gels, who've got corns and wants to meet yer sweethearts, here's corn salve, a penny a packet!'

'Coughdrops, a penny a packet!' was barked by a hoarse throated vendor with a big black tin trunk full of cough drops which stood beside him in the market place. This man sported a moustache which was as large and bushy as a yard brush. 'Old Wolfy', as the boys called him, was always to be seen at the Nottingham football matches, selling his wares, dressed in a shabby suit and an old bowler hat.

A man called 'Juicy Yemons' was good bait for the teasing of the local Nottingham lads. This unfortunate hawker of lemons who usually stood outside the Mechanics' Hall 'talked half short-tongued and half something else'. He was quick tempered and if anyone dared to look at his basket without buying one of his 'yemons' he soon told that person where to go.

Another well known Nottingham character was 'Tommy Tittlemouse' who sold 'racing certainties', gained from information straight from the 'orses' mouth, at a great financial outlay to himself.

One puzzling cry was that of a fruit hawker who used to shout:

'Apples a pound pears,
Plums the same!'

He took his fruit round on a handcart which he pushed down the middle of the street. Then he would stop and shout again his strange nonsense call.

It would be foolish to think that all these folk went about selling and shouting in sweet harmony. Disturbances did break out between the street hawkers. On one

unforgettable occasion, 'Professor' Brown the 'Swell Quack Doctor' came to grief with a 'Model Nottingham Auctioneer' when they had a massive quarrel in front of a large crowd of people. The Nottingham *Owl* of 14th May 1886 reported that the 'Knight of the Hammer' had called the 'Learned Professor' an ignorant quack and said all his medications were worthless. He then went on to malign the quack's lady friend who gave lectures from his gilded chariot. The 'Model Auctioneer' in turn was accused of being a scoundrel and an ignoramus of the deepest dye.

Most of the lively old characters had gone by the late 1920s or early 1930s; all the men and women who had scraped some sort of living from calling their wares and mending and selling myriads of things which kept a house and its inhabitants ticking over. The more outrageous the character, the better the chance of a sale. These hawkers and opportunists throbbed with the city and shuffled into its outreaches with colourful determination. Quack doctors produced 'miracle cures', Punch and Judy shows performed in the streets and until the end of the 19th century, even bears danced in Nottingham.

Pins and
Kitty Hudson

KITTY Hudson was born at Arnold in 1765 but at the age of six years she went to live with her grandfather at Nottingham. He was the sexton of St Mary's church and arranged for Kitty to clean the building as a contribution towards her board and lodging. It was within the hallowed walls of the mother church of Nottingham that the child's addiction was formed.

If Kitty found a pin whilst sweeping the floor she popped it into her mouth and gave it to her grandfather's housemaid upon her return home. This greatly amused the servant who egged the child on to do the same the next day.

'Kitty,' she would say, 'If you'll get me a mouthful of pins I'll give you a stick of tuffy!'

The little girl loved her toffee and quickly grew to rely upon the sensation of pins in her mouth. Soon life became unbearable without them. She could neither eat without several stuck into her mouth, nor could she sleep without them. Kitty Hudson was addicted to pins.

Time passed, her back teeth were almost worn down to the gums through grinding on pins but pain in her mouth no longer satisfied her craving. She turned her body into an agonising but secret pincushion with limbs numbed and swollen from her cruel attentions. Eventually her right arm became so painful she had to be admitted to the infirmary.

Upon examination two pins were extracted from deep in the flesh above the wrist and many more were pulled from that hideously swollen and pulsating arm. However this did not stop the addiction and Kitty was to return to the infirmary on many occasions to have pins and needles taken from all parts of her body.

The intense pain resulted in many violent convulsions and her life frequently hung by a thread. Then the miraculous happened. During hospitalisation she met an old playmate from her days at Arnold whom she had not seen since living at Nottingham. He had just had an eye removed, but with his other he soon fell for the charms of pathetic Kitty, who was now 20 years old. Later she confided that he had promised that even if she lost every limb from her body he would love all that was left. Their relationship blossomed into a successful marriage and Kitty conquered her reliance upon sharp objects.

Amazingly her body grew strong again and in between bearing 19 children, of whom all but one reached maturity, Kitty carried the post each day by foot from Arnold to Nottingham. She became a popular and familiar figure, always dressed in a small bonnet and a man's spencer (a short jacket) which was made of drab cloth. A coarse woollen petticoat, worsted stockings and strong shoes completed her ensemble and she carried the huge leather mail bag over her shoulder with vigour.

After her husband died in 1814 Kitty went to live with friends in Derbyshire. She presumably lived to a good age and is buried in that county, her terrible childhood long forgotten.

The Rufford Mine Disaster

O N the night of 7th February 1913, 14 brave men were killed in a pit disaster at the Bolsover Colliery Company's new Rufford Sinkings on Lord Savile's estate. This tragedy was yet another addition to the long list of mine disasters, but according to reports of that time it was unique in the annals of pit sinking and its terrible results plunged Nottinghamshire into deepest mourning.

The cause of the accident was simple enough. A faulty nail caused the awning of a temporary rain shelter to fall on the head of the engine-man, Sidney Brown, just as the swiftly revolving drums drew a seven ton steel water barrel from the shaft. He was therefore unable to check the barrel, which ascended to the headgear. Here a patent appliance, known as the Ormerod hook, failed to hold the heavy water-laden barrel, which hurtled at great speed back down into the workings.

On a platform, 145 ft below, a gang of 18 men was at work. The barrel smashed into them with terrific force, instantly killing 13 and seriously injuring another man who later died in Mansfield Hospital. The other four escaped by hanging on to the debris floating in the icy cold water at the bottom of the shaft.

As so often occurs at such times, the heroism and

kindness of other workers was tremendous. Immediately, without thought of their own safety, men went down the mine shaft to rescue their colleagues and tend the wounded. Mr Cook, the master sinker, with some 35 years of mining experience, declared, 'I never meant to sleep until I got the poor fellows out.' The Mayor of Mansfield, Mr J. P. Houlton JP, paid a high tribute at the inquest to both Mr Cook and his mates Dick Barratt and John Clarke for their bravery in dealing with the situation. 'It speaks volumes for the devotion, self sacrifice and comradeship of the sinkers, that when the appeal went forth for volunteers to undertake this hazardous task there was a ready and ungrudging response.'

All through the weekend the men worked night and day to cope with the rapid influx of water in the shaft, but eventually a diver had to be sent down. It was not until the following Tuesday evening that the first two bodies were recovered. Drags had to be used to draw the remainder of the men from their watery grave.

The Sunday following the recovery of the bodies resounded with prayers for the dead and those they had left behind to mourn their loss. Messages of sympathy were sent by the Secretary of State and other important national and local figures and a fund of £2,000 was eventually raised for the dead miners' families.

The inquest was opened at Mansfield on 12th February and closed on 26th February. The verdict? Accidental death with no criminal blame attached to any person.

This verdict was not in accord with the findings of HM Inspector of Mines, Mr W. Walker, whose report and conclusions were eventually issued in a White Paper. It was stated that since the accident a better hook had been designed and tested, and although the margin of safety was nearly doubled, it still did not appear to Mr Walker to be sufficient for safe working in a sinking pit.

Although the whole of the arrangements of the surface and the shafts were all that could be desired, it was

regrettable, said Mr Walker, that the winding engine-man had erected and continued to use so flimsy and dangerous a covering over his chair, and also that the manager and engine-wright had allowed it to be used. They were all guilty of an error of judgement which was directly the cause of the loss of 14 lives. Walker expressed the hope that the lessons learned in that accident would result in management ensuring that nothing of a temporary or insecure character was used about the winding arrangements at this and other sinking pits in the future.

On the 13th, 14th and 15th February the families and friends of the victims went to the churchyard to bury their men. Andrew and Frank Bagnall, Thomas Jordan, Joseph Battney, John Tomilson, Jesse Hart, Henry Scott, Walter Storey, John Knowles, Herbert Woodward, James Wigman, Patrick Mulligan, William Hollins and Frederick Paddon were to enter the ground for the last time. Their conveyance was not the customary lift which they had used all their working lives but a coffin, and all the time the furnaces and grates of England demanded to be fed, oblivious of the cost.

One Month with Nurse Thatcher

WHEN home confinements were normal practice it was customary for many middle class families to employ a nurse for one month to live with the family and care for the mother and her baby.

A new father wrote an article in the 26th February 1881 edition of the *Nottingham Society* complaining of the enormous appetite of their 'monthly nurse', Mrs Thatcher, who settled upon his house like a single-minded locust.

This woman had a rapacious appetite and continuously gorged herself on snacks, colossal amounts of victuals and tumblers of alcohol without suffering any ill effects. The 'British Husband' appears to have spent much of his time anticipating the woman's death or at least discomfort from her continuous gluttony during her terrible stay under his roof. However, Nurse Thatcher was made of stronger metal.

He wrote the article to alert the whole of Nottingham to the culinary insatiability of the dreadful woman. 'I certify, on my word of honour as a British Husband Housekeeper, that the following copy is correctly taken from my wife's entries in my pocket-book, checked impartially by the cook's slate.' He then proceeds to list a sample menu for a typical day during Nurse Thatcher's sojourn with his household.

'7 am. Breakfast — tea, buttered toast, half-quartern loaf, bloaters, three eggs, and bacon.

9.30 am. First morning snack — mutton chops, glass of sherry and plate of biscuits.

11 am. Second morning snack — a basin of tea and a sponge cake, with tumbler of brandy and water.

12.45 pm. Dinner — a roast loin of mutton and mashed potatoes, with ale spiced and warmed; after dinner a tumbler of hot gin and water.

3 pm. Afternoon snack — a glass of sherry and plate of biscuits.

4.30 pm. Tea and pile of muffins.

7 pm. Evening snack — stewed cheese, toast and a tumbler of brandy and water.

9 pm. Supper — juicy steak and two glasses of beer, stewed cheese and tumbler of gin and water.'

'At 4.30 am on the morning of Tuesday my wife was awakened by hearing the nurse walking up and down the room, and sighing bitterly. The following conversation then took place between them: My Wife: "Are you ill?" Mrs Thatcher: "No, hungry."

'I can certify the above list correctly, and even moderately, represents Mrs Thatcher's daily bill of fare for one month. I can assert, from my own observation, that every dish, at every hour of the day, which went up to her full, invariably came down from her empty.

'After the breakfast, the two morning snacks, and the dinner — all occurring within the space of six hours — she could move about the room with unimpeded freedom of action; could keep my wife and the baby in a state of the strictest discipline; could curtsey magnificently when the unoffending master, whom she was eating out of house and home, entered the room, preserving her colour, her equilibrium, and her staylaces, when she sank down, and when she swelled up again, without the apparent vestige of an effort.

76

'During the month of her devastating residence under my roof, she had 248 meals, and she went out of the house no larger and no redder than she came into it.

'I leave this case in the hands of the medical and the married public. I present it as a problem to physiological science. I offer it as a warning to British husbands with limited incomes. While I write these lines — while I give my married countrymen this friendly caution — my wife is weeping over the tradesmen's bills; my children are on half allowance of food; my cook is worked off her legs through having to do housemaid's work in addition to her own; and my purse is empty.

'Young husbands and Nottingham friends about to marry, commit to memory the description here given of my late monthly nurse, who is at the present time perambulating this town, "seeking whom she may devour".

'Avoid a tall and dignified woman, with a flowing style of conversation, and impressive manners. Beware, my struggling fellow toilers along the heavily-taxed highways of domestic happiness — beware of Mrs Thatcher!!'

The Mothering Sunday Revival

THE origins of Mothering Sunday go back to ancient times when the religious festival of visiting the Mother Church was held on the fourth Sunday in Lent. It was also customary for children living away from home to call on their mother and bring her small gifts.

Over the centuries the custom lost its popularity, until the early years of the 20th century when it was reinstated through the efforts of Miss Constance Penswick Smith, the daughter of the vicar of Coddington, near Newark.

Constance was one of seven children and her four brothers entered the church ministry. She was a home loving girl, who until the age of twelve was educated at the vicarage by her mother. She then attended a dame school at Newark and later went to a school for young ladies at Nottingham.

After finishing her education she spent two years as a governess in Germany. Upon her return to England she trained as a chemist's dispenser and in 1905 was employed by a Nottingham skin specialist.

In 1907 Constance learned that the Americans had started their own Mother's Day which was completely removed from the Church. They were also trying to bring the custom to England. In retaliation against what she

considered to be a profane practice, she commenced her own campaign to revive the traditional Mothering Sunday and formed the Mothering Sunday Movement. She eventually quit her dispensing job and moved into a house in Regent Street, Nottingham, which was to be the movement's headquarters. Later everything was moved over to Marston Road, where she remained until she died.

In 1914 the United States Congress stipulated that the second Sunday in May was to be designated Mother's Day. Miss Penswick Smith was undeterred by this announcement and continued with her hard work and the writing of a book entitled *The Revival of Mothering Sunday* which was published in 1921.

She canvassed and bombarded local places of worship with her literature and leaflets and gradually the tradition was reinstated. Her family connections with the Church helped, but her energy and enthusiasm was phenomenal.

Whilst working as a dispenser Constance boarded at the Girls' Friendly Society in Nottingham, whose warden was Miss Ellen Porter. The women became lifelong friends and eventually shared a home together, with Ellen assisting with the campaign work which was totally financed by Constance.

Constance wrote Mothering Sunday services and hymns and designed special cards for Sunday school children to colour and give to their mothers. Stories and plays promoting the tradition were written and mailings sent as far away as Australia and New Zealand. Much support was given by the Penswick Smith brothers and also by Rev Killer, vicar of St Cyprian's church in Carlton, Nottingham.

Killer wrote several hymns for the festival and in 1936, when the new St Cyprian's was dedicated, a canister holding leaflets and books regarding the festival was buried under the altar.

The movement's leaflets were very stirring. The one for Mothering Sunday, 7th March 1937 urged everyone to

'Take part in this festival of our home blessed by Mother Church, and so help to strengthen the family life of our nation.'

The reinstated traditions of the fourth Sunday in Lent were very pleasant. Young children would gather bunches of primroses and violets, which were taken to church for blessing and presented to their mothers. Violets were considered to be emblems of a mother's love and it was said that 'He who goes a-mothering finds violets in the lane.'

It was also customary to eat little simnel or 'Ladoma' cakes on this day, the word 'simnel' probably derived from the Latin simila, fine flour.

Children who were away from home in service were given a day's holiday to visit their mother. They would take with them simple gifts which they had made throughout the year, perhaps an embroidered sampler or cushion or a little wooden box.

Nottinghamshire had its traditional Mothering Sunday dish of 'fermity', made from soaked whole grains of corn, boiled in water, drained and mixed with hot spiced milk.

'Clipping the Church' was another custom often performed at this time of year, when the congregation joined hands and encircled the church, 'clipping' or embracing their place of worship.

After years of unceasing hard work the Misses Penswick Smith and Porter placed Mothering Sunday back on the calendar. Constance worked vigorously until her death on 10th June 1938. Ellen Porter continued to dispatch leaflets and other literature until her own death four years later.

Despite the continued efforts of Miss Penswick Smith's family to promote the religious aspect of Mothering Sunday, they have been unable to stem the change to the present highly commercial 'Mother's Day'. It is sad to think that there are now very few violets growing along the banks of the country lanes where children once went a-mothering, seeking simple emblems of their mother's love.

Putting the Pig on Harrison

THE Nottingham Race Course has seen many fortunes won and lost, but according to the *Nottingham Journal* the race between Granny from Belper and Harrison from Nottingham on 21st April 1773 caused many folk to risk losing more than their proverbial shirts on this 'dead cert'.

Fifteen thousand very excited people from all over the country converged upon the track to see these two great runners compete for a purse of £200, which in those days was an enormous prize. They had to run ten miles, which was five times round the race course, and they had to run naked.

Harrison, the local lad, was the favourite and his backers were so certain of his supremacy that according to the *Journal*, 'Many of them sold their beds, cows and swine, to raise money to make bets; and others pawned their wives' wedding rings for the same purpose; for, as the odds were seven to four and three to two, in favour of Harrison, the temptation became so much the stronger, and very considerable bets were laid: the highest odds we hear of, were £100 laid by a gentleman in the Stand, to 30.'

At two o'clock the competitors, stripped of their clothes, were poised at the touchline and were soon streaking down the track at a swinging pace. Granny held the lead for seven miles and looked set to win. Doubtless Harrison's backers were rehearsing their excuses to their deprived wives

between screaming for their man, when their prayers were answered.

Fourth time around the track Granny fell and injured his right leg. Harrison gained nearly 50 yards. Applause thundered throughout the race course but Granny would not give up. He pushed forward in the downhill section, but stumbled and almost fell to the ground, totally winded. 'His courage and strength then failing, he gave up the contest, with tears flowing from his eyes.' The race had taken 56 minutes and two seconds.

The lucky punters celebrated with good Nottingham Ale before redeeming their goods from the pawnbrokers who, win or lose, always thanked God for the gambling man.

Mad, Bad and Dangerous to Know

IT was Lady Caroline Lamb, the wife of the future Viscount Melbourne and Whig Prime Minister from 1835–1841, who wrote in her diary on the night that she first met the poet Lord Byron that he was 'mad, bad and dangerous to know.' She might have added that this applied to several others of the Byron family.

The Byrons' family home was at Newstead Abbey, which then stood on the edge of Sherwood Forest. The abbey had been found by Henry II circa 1170 to house the Austin canons. After suffering at the hands of Henry VIII both the abbey and Hucknall church were purchased by Sir John Byron and it became a private house in 1550. Over the years, if local tales are to be believed, the place became chock-a-block with ghosts and apparitions including a White Lady, a Black Friar, a Goblin Friar and a Byron ancestor known as 'Sir John Byron the Little with the Big Beard.'

Byron's great-uncle William, alias 'Devil Byron', was said to be haunted by the spirit of a sister, to whom he refused to speak for many years because of a family scandal. This was despite her heartrending appeals. He was also known as 'The Wicked Lord', having killed a Nottinghamshire neighbour, Mr Chaworth from Annesley Hall, in a drunken skirmish in the Star and Garter in Pall Mall, London, on 26th January 1762. He was acquitted of

murder but found guilty of manslaughter. After paying a fine he was immediately set free and returned to Newstead, where he lived for the rest of his days in impoverished squalor and with women of a certain reputation.

William's seafaring brother, with the rank of Vice-Admiral and the reputation of a womaniser, was known as 'Foul Weather Jack'. He earned the title as on most occasions when he set to sea his ship encountered terrible storms.

'Foul Weather Jack' died in 1786 having disinherited his son, 'Mad Jack', because of his debauched lifestyle. With a passion for women and their money, young Jack Byron had run off to France with the Marquis of Carmarthen's wife and her fortune of £4,000 a year. She obtained a divorce from her husband and married 'Mad Jack' but died shortly after giving birth to their daughter Augusta.

Jack Byron returned to England and eventually met a wealthy Scottish girl, Catherine Gordon, who had an irresistible fortune of £23,000. They married in May 1785 but Catherine's money was soon eroded by her spendthrift husband and in no time she was forced to sell her family home in Scotland. She and 'Mad Jack' fled to France to escape from their creditors, but Catherine returned to England in time to give birth to her son, George Gordon, on 22nd January 1788.

The future poet's first home was a dingy, small back room off Oxford Street, London. George was born with deformed ankles and a clubfoot, which were to cause him great mental and physical pain for much of his life. Jack Byron travelled about France enjoying freedom from his responsibilities, which he celebrated in a series of brief love affairs. Shortly before George's first birthday he died. With just a small income to live off, Catherine Byron moved with her son and his nurse to better accommodation, but she became mentally unstable.

The young and fatherless Byron thus had an unstable early upbringing with a mother who was cursed with bouts

of terrible temper and hysteria, interspersed with periods of more gentle behaviour. He was a beautiful plump little boy with a mop of auburn curls, and said to be the butt of cruel teasing by other children concerning his ankles and clubfoot, which caused his limping gait. His mother took him to a succession of doctors, quacks and surgeons for what often amounted to torturous treatment, which at one stage involved having his foot screwed at an angle in a wooden machine.

Byron bore the pain with great fortitude and when his Latin tutor remarked to his pupil, 'It makes me uncomfortable to see you sitting there in such pain as I know you must be suffering,' young George is said to have replied, 'Never mind me, Mr Rogers, you shall not see any signs of it in me.'

In 1798 'Devil Byron' died and George Gordon inherited at the age of ten years in default of the fifth Lord's grandson and rightful heir, who had been killed in Corsica.

The sixth Lord Byron and his mother lost no time in going to Nottinghamshire, where they were horrified to find the Abbey in a hopeless state of repair. Reception rooms were used as hay stores, the roofs were leaking. There was very little furniture as anything of value had been seized by the 'Wicked Lord's' creditors. The estate had long been neglected with its farm buildings abandoned and fields and parkland without stock.

Despite the dereliction young Byron and Catherine were enchanted by the peace and natural beauty which engulfed Newstead. They were especially fond of the large quiet lake which had once been the scene of the fifth Lord's strange passion for mock 'sea' battles. He had fake fortresses and castles built along its shores and mimic fleets sailed its waters firing off salvoes of destruction.

When mother and son stood together beside the lake on their first visit after the inheritance, they must surely have known about the unsubstantiated stories of treasure said to be buried in its waters. The rumours may have stemmed

from the great brass eagle with wide spread wings, standing on a pedestal, that was fished up from the deepest part of its waters. It had doubtless served as a stand or reading desk in the abbey chapel, to hold a folio bible or missal. The sacred relic was sent to a brazier to be cleaned and it was discovered that the pedestal was hollow. Inside were a number of parchment deeds belonging to the abbey, bearing the seals of Edward III and Henry VIII. The eagle was transferred to the church at Southwell.

Catherine Byron stayed on at Newstead and her son lodged with a family in St James's Street, Nottingham, where he was taught the classics. He was later educated at Harrow, his mother having obtained a pension from the civil list which paid for his school fees.

Byron is said to have shown signs of his future talents at a very young age, during an early visit to Newstead, as remembered in a tale recounted by his nurse. An elderly lady frequently visited his mother and her remarks never failed to irritate the little boy. The old lady had some strange ideas and one concerned the soul, which she thought took flight to the moon after death as a first stopping place before flying on to Heaven. One day the visitor had especially annoyed little George who flew into a violent rage. His nurse enquired, 'Well, my little hero, what's the matter with you now?' The peeved child broke into the following doggerel lines, which he frequently repeated and called his 'first dash into poetry.'

'In Nottinghamshire town, very near to Swine Green,
Lives as curst an old lady as ever was seen;
And when she does die, which I hope will be soon,
She firmly believes she will go to the moon.'

Whilst living at Newstead, Lord Byron found a large human skull. He assumed this to belong to some 'jolly soul of a friar' who had lived there before the Dissolution of the Monasteries. He converted this cranium to a drinking

vessel which he called 'Friar Tuck' and sent it off to London to be mounted. On its return to Newstead, Byron instituted a new order at the abbey, making himself Grand Master, or Abbot of the Skull. The twelve members of the order and their 'Abbot' wore black gowns when they attended their chapter meetings. The skull-goblet was filled with claret at their ceremonies and handed amongst the fraternity, who were said to have had a great deal of fun at the expense of the rightful owner of the head. The skull is said to have been eventually buried beneath the floor of the chapel at Newstead Abbey.

Byron had been warned in his youth by a fortune teller to 'Beware your 37th birthday'. In 1823 he became involved in the Greek struggle of independence and he died at Missolonghi on 19th April 1824, while training troops. He was 36 years old. A period of three weeks mourning was decreed for the dead poet. Following an autopsy his heart and brain were placed in separate urns. The lungs were buried at a funeral service in the local church of St Spiridion on 22nd April.

Byron had announced on his death bed that he wished to be buried in England, and so the body was embalmed in a casket containing 180 gallons of spirits and was shipped to England, where it arrived on 29th June 1824.

The Dean of Westminster refused to have Byron buried in the Abbey and he was made similarly unwelcome at St Paul's. It was eventually arranged for his remains to be taken to Hucknall Torkard, Nottinghamshire, and deposited in the family vault. A huge crowd watched the small funeral procession leave London.

On the 15th July 1824 the procession reached Nottinghamshire and the noble poet rested at the Blackamoor's Head inn. Church bells tolled and special constables were shipped in to control the crowds. The following day some 40 local gentry joined the funeral courtege and Byron was laid to rest in the vaults of St Mary Magdelene in company with 15 of his ancestors and

alongside the 'Wicked Lord'. The poet's coffin was draped with a velvet cloth with coronets placed at each end. On a chest enclosed inside the coffin was the inscription, 'Within this Urn are deposited the Heart, Brains etc of the deceased Lord Byron.'

However, Byron was not to lie undisturbed for rumours persisted that the body which lay in the Byron vaults at Hucknall Torkard was not that of George Gordon. Therefore in 1938 the local vicar received permission from the Home Office and the surviving Lord Byron to have the poet's tomb opened in order to record the contents.

On the 15th June a small group of people made their way down the steps which led to the vault. The floor was littered with decaying wood and scores of bones, but there was the poet's coffin, still intact and shrouded in its fraying cloth with the two coronets in situ.

The lid was carefully opened and there was Byron, 114 years into eternal rest but in a perfect state of preservation except for his hands and feet. His clubfoot had fallen off and was at the bottom of the coffin and his heart and brains remained sealed in the urn. The coffin was photographed but not its contents.

On 8th May 1969 a memorial to Lord Byron was conducted by the Dean of Westminster, having been petitioned by the Poetry Society of Great Britain.

Of Flood
and Tempest

THE river Trent flows through the centre of
Nottinghamshire, the great highway for goods and
merchandise in times past. Today banks are lined with
power stations, which continue to expand in number. In
the past mills throbbed along its banks, whilst willows
grown for cricket bats and basket making have had their
roots nourished by the old river. This watercourse
provides the main source of drainage for the county and
has a flood plain two miles wide in some places.

The river has been the source of many terrible floodings.
Towards the end of the 16th century a storm devastated
Wilford and Bridgeford, which lie to the south of the river
Trent. What was described as 'marvellous tempest of
thunder' was said to have beaten down all the houses and
churches; 'the bells were cast to the outside of the
churchyards, and some webs of lead rolled 400 ft into the
field, writhen like a pair of gloves.' The river flooded the
area for a quarter of a mile and trees were uprooted. 'A
child was taken forth of a man's hand, two spear lengths
high, and carried an hundred ft, and then let fall, whereby
his arm was broken, and so he died; five or six were slain.
There fell some hailstones that were 15 inches about.'

One very strange event which was known locally as the
'Terrible Tempest' is said to have happened in November
1785. The day started well with a clear sky and agreeable

temperature for the time of year. At about eleven o'clock in the morning the sky became very overcast, before it started to rain in torrents and the wind roared. Suddenly, around two o'clock in the afternoon, everything was hushed in a deathly calm. People from just outside Sneinton reported a weird and frightening sight at about four o'clock.

An immense water spout was proceeding from a dense cloud about a quarter of a mile south of the river Trent, and moving slowly towards it. People standing within its path said that as the spout passed over, it bent the branches of strong trees almost to the ground.

As the cloud got nearer to the river the water became strongly attracted by it. When it crossed the Trent the cloud or spout was only some 30 ft from the surface of the water, which heaved and tossed in great agitation. Sightseers standing on the Trent Bridge described the phenomenon as being 'a huge black inverted cone, terminating nearly in a point, and in which they perceived very plainly a whirling spiral motion, accompanied with a rumbling noise, like distant thunder.' It was calculated that the middle of the column was nearly 20 ft in diameter.

After passing the river it ascended slowly and majestically in a north-easterly direction and hit Sneinton with a vengeance. Thatched roofs were completely ripped from cottages and barns and tossed into the air like pieces of paper. Apple trees were uprooted. One with a four ft diameter trunk was broken off close to the ground as easily as snapping a twig. The column flattened a large and substantial barn, devastated the adjoining house and tore up a huge sycamore tree. The rain poured down and joined the noise of the raging wind, 'and the terrific aspect of the yet undissolved waterspout, floating as it were, a little over [the spectators'] heads, produced a feeling of alarm and confusion which was impossible to describe.'

Several of the Sneinton folk were thrown into the middle of a hedge and one 14 year old boy was carried up and over it and landed uninjured in the adjoining field.

The drinkers in a nearby public house all complained of terrible sensations in their heads as the storm passed over, and their discomfort lasted several hours. Flashes of lightning darted from the tornado whilst it was passing over the fields, and as it rolled over the Colwick Hills the people in the tavern saw it contract and expand in a strange manner, as though it had been under the influence of electrical attraction and repulsion from some extraneous forces.

In times when winters were very severe the river was liable to break its banks when the thaw melted the ice and snow and swelled its waters to bursting point. In February 1795 there was a terrible flooding of the river Trent which inundated most of the valleys of Staffordshire, Derbyshire and Nottinghamshire.

On Christmas Eve 1794 there had been an extremely harsh frost, followed at intervals over many days by severe snow storms. Everywhere remained frozen until around the 9th February when a rapid thaw set in. The river Trent was sent into a whirling flooded frenzy, carrying away vast sheets of half melted snow, rails, timber, posts, houses and sheep. It even flooded the lower parts of Nottingham where the residents of Narrow Marsh were imprisoned in their homes for two days and nights with the water lapping to a depth of three ft.

The canal banks were washed away and many cattle and sheep perished. West Bridgford lost 19 beasts and 30 sheep and at Lenton upwards of 400 sheep were drowned. The new 'Ten-Arch Bridge' or Trent Bridge was rendered useless. An eye-witness wrote, 'in short the scene the Trent presented, bearing down in its mighty stream, horses and sheep, haystacks and trees, and farm produce of all kinds, was amply sufficient to show the unprecedented extent of the calamity.'

Nineteen years later to the day, it seemed likely to happen again, when the 'Thirteen Weeks Frost' set in. The river Trent was completely sealed with a thick sheet of ice.

Hundreds of skaters, sliders and others of all ages and states of fitness were to be seen daily enjoying their new sport. Great fires blazed for hours at different points between Wilford Ferry and the Trent Bridge.

There was a great fear that once the thaw set in the river would flood as it had done on so many previous occasions. A mechanical device was set up on the Trent Bridge so that once the temperature rose above freezing, large balls of cast iron with ropes attached could be crashed onto the ice, which could then be carted away. This would preserve the bridge and lessen the risk of inundation by securing a free channel through the arches for the rising water.

On 7th February there was a slight thaw, although followed by renewed frost, but whilst conditions were good the huge balls pounded the ice and large chunks of the stuff were transported to safety. Occasionally the piers of the bridge were shaken as great ice floes knocked against their structure. The customary huge crowd of people gathered to watch the work and, if lucky, witness at first hand any accidents. The bridge was saved but the meadows resembled an inland sea.

The flood of 4th December 1910 was again the result of thawing snow and the improvements in drainage and dredging of the river bed proved totally inadequate. The floods continued to rise between Nottingham and Gainsborough and one of the most remarkable features was the flooding of the Midland Railway line from beyond Attenborough to the centre of the bridge of the Nottingham Midland station. All trains between Nottingham and Trent had to plough their way for five miles through water three to four ft deep in places, yet every locomotive got through safely.

The Trent is now a tamed river, its banks fortified by flood banks, piles, stones, cement and even sunken barges. It is a lifeline which has brought wealth to the region, and remains Nottinghamshire's vital artery.

Beating
the Bounds

NOTTINGHAMSHIRE has always participated in the traditional custom of Beating the Bounds at Rogationtide, and the custom of walking the boundaries still exists in some of its parishes.

The Rogation Days which occur before Ascension Day are a survival of two ancient Roman customs, Ambarvalia and Terminalia, which occurred in May and June when sacrificial animals were taken around fields and boundaries and offered to Mars in exchange for good crops. Like so many pagan customs, these were absorbed into Christian festivals and therefore, three days before Ascension, priests and parishioners processed their territory, carrying peeled wands and praying for blessings on the crops and at the same time the boundaries were marked. The ritual was known as 'Beating the Bounds' and was a good way for people to remember their boundaries in the days when maps were few and inaccurate and not many people could read.

At the Reformation the ceremonies and practices were deemed objectionable and were abolished and only the 'useful and harmless part of the custom retained.' Yet its observance was considered so essential that a homily was prepared for the occasion and injunctions were issued requiring that for 'the perambulation of the circuits of parishes, the people should once in the year, at the time

accustomed, with the rector, vicar or curate, and the substantial men of the parish, walk about the parishes, as they were accustomed, and at their return to the church, make their common prayer.'

And so on this day the parishioners were entitled by law to trespass on lands and even enter private houses if these stood on the boundary line. If a canal was similarly cut then it was necessary for some of the parishioners to pass through the water. When a river formed a boundary the parishioners either had to pass through it in boats or some of the party stripped and swum in it, or boys were thrown into it.

The young children had the boundary marks impressed upon them by being bumped or whipped at each important point. They were thrown into ponds and rivers, forced to climb over roofs of dwellings which straddled the boundary and bumped upon boundary marker stones. In later years should any boundary dispute arise, they would have painful memories of just where the line of demarcation lay.

In 1874 Alderman Whitehead issued a pamphlet describing the perambulation around Nottingham as he knew it.

'On Perambulation Day the committee and other burgesses, with axes, crow bars, shovels and other implements, walked over the various lands subject to common-right, claimed to have a road through any buildings recognised as encroachments, and by the execution of something like Lynch Law prevented these encroachments increasing.

'One year in particular, about 1832, was memorable for the incidents the perambulation produced. Assembling at the Three Crowns in Parliament Street, we proceeded to the corner of Park Row. Each building there was entered by a door, and if there was no second door a hole was quickly made in the opposite wall. Then Chimley's buildings at the top of Derby road were similarly visited.

Passing thence to the site of the present General Cemetery, the formidable party marched down the fields in a line with Back Lane (now Wollaren Street) to Dr Lavendar's close, the site of Whitehall's factory (at the corner of Goldsmith Street).

'A barn in this field was gently treated, the door being merely opened and closed again because "the doctor" in antique wig and George III costume, stood on the opposite side of the way in the recess which still exists. His housekeeper [stood] by his side in front of them on the low wall, bearing trays loaded with smoking punch and rich plum cake. Everyone being cheerfully and freely supplied with as much as he could eat and drink, the "chairman" of the committee gave the order to march up Larkdale, now Waverley Street, passing the old red brick house that stood at the corner of Roper's Close, now Goldsmith Street, on which was generally painted by some devout hand, "The Way to Hell, to the Races."

'We crossed the road to the old cottage owned by Mr Duggan, an Irish gentleman who had obtained possession by marrying an English lady.

'Mr Duggan, dressed in a blouse fantastically braided like that of a stage brigand, flew into a passion, brandished a wide mouthed blunderbuss in our faces, and swore he would blow out the brains of anyone who dared to trespass upon the domain he claimed exclusively as his own. The surprise was unexpected and the party retreated with great precipitancy and in much disorder. On rallying a council was called and it was agreed to depute some three or four to reason with the enraged gentleman. The result was a truce, and the deputation being allowed to pass through the house and grounds to perpetuate the right of the burgesses. The rest, with the tag-rag and bobtail, were content merely to look over the gate.'

Not all parishes inspected their boundaries during Rogation, for R. Mellows recorded in his book *Then and Now*, published in the 19th century, that West Bridgford

had its bounds beaten by the Mickletorn Jury every 4th
September.

The Jury was sworn in on the previous night and set off
from the Town Hall at eight o'clock the next morning.
Their course was about 15 miles and they usually returned
to the Town Hall at eight o'clock that evening to record
their proceedings.

The Jurymen divided, one part taking a boat from the
canal, going down the Trent, then walking by and touching
the boundary stone on Barrow Hill Farm, going by old
Lady Bay Bridge and the Brook Bridge. The other part of
the Jury went to the west and the south by the 'borough
proper' boundary, extending to the 'Stone Man' on the
Melton Road, the two parties meeting up at the Town
Arms.

Each year they would sing a different 'Mickletorn Jury'
song and the chorus of the long entertainment for 1850,
composed by Mr W. Bradbury, their poet, went:

'Shoulder your spades and march away,
The sun shines bright, 'tis a glorious day!
Our Foreman's the King, whom we all obey,
We serve on the Mickletorn Jury.'

And what about modern Nottinghamshire? In some
places the old boundary customs exist. For instance, each
Rogation Monday (commonly known as Mickleton
Monday) at Gringley on the Hill, a procession climbs to the
top of Beacon Hill to ask for God's blessing on the
surrounding countryside. At Tithby-cum-Cropwell Butler,
weather permitting, the parish priest leads his
congregation on Rogation Sunday, together with the
church choir from Crompwell Bishop, to bless the local
farms.

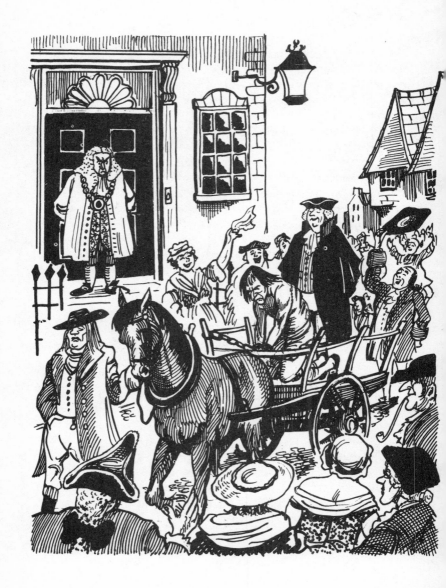

The Whipping Judge

ENORMOUS personal powers were once vested in magistrates, who could, at their individual discretion, inflict severe punishments in the name of law and order. In 1761 Robert Huish, JP and Mayor of Nottingham, ordered a punishment for Jos Hollingworth which seems out of proportion for his crime. In fact even in those days he was compelled to issue a public statement to vindicate his judicial conduct.

Apparently on 8th August Hollingworth had called on the house of this Justice of the Peace who lived at Goose Gate and knocked violently upon his door. Accompanied by a large gang of friends, he had come to demand the reason why Huish had put him in the stocks. The JP replied, 'I told him I never did; nor did I know who it was that put him in. He told me I lied, for he knew that I had put him in.'

Hollingworth was then told to go about his business or it would be the worse for him. The reply was 'He said that he valued me not, nor did he care for either mayor or horse, or what such scoundrels could do at him, for that he had been in the Bridewell at Southwell and at Mr Parr's.' Mr Parr was the Governor of the County Gaol, Nottingham.

The mayor sent for a police constable, who took half an hour to turn up, and the two men were obliged to remain arguing at the mayor's front door for that duration.

Gradually a large crowd began to form and word soon got around the town to go to Gocse Gate if anyone wanted a bit of fun.

Hollingworth was ranting 'Such scoundrels as Alderman Butler, and altogether, I don't value what any of you can do to me, d--n you, I value you not.'

The mayor fuelled the situation by demanding a shilling fine the first time Hollingworth swore at him, it being within a magistrate's powers to make such an imposition. This penalty was useless for 'He d-d me, and could not find one.'

The situation attracted an audience of several hundred, most of whom stood laughing at the mayor and shouting advice to Hollingworth.

Eventually Constable Billings turned up and according to the JP-mayor was 'confounded at what he (Hollingworth) said and did; and though I exhorted him several times to go away and be quiet, it was to no purpose; for he said he had a tongue, and no horse nor mayor should prevent him saying and doing what he pleased.'

The mayor lost his temper and ordered the constable to place the man in the stocks, which were situated in Nottingham Market Place, near the Malt Cross. Hollingworth was dragged off by the scruff of his collar, followed by the crowd like the Pied Piper of Hamelin. In no time at all he had escaped from his rustic prison, possibly helped by his large number of sympathisers.

When Huish found out he fell into a terrible temper and demanded that Billings should scour the town and return the prisoner in great haste if he wanted to keep his job. The PC was soon back at the mayor's front door with Hollingworth writhing and swearing in his clasp and the crowd cheering and jeering. Hollingworth was then ordered to be taken to the dungeons in the House of Correction where he stayed for a week and was fed on a diet of bread and water.

Robert Huish takes up the story, 'I ordered the keeper of

the House of Correction to whip him there, and then have him put into a cart and drawn by my door, for an example, and to terrify anybody whatever from vilifying and degrading magistracy as he did, and from doing the like in the future! And let him be drawn through the Market, that the country might see him.'

He explained that he had issued this statement to tell the public why he had delivered this punishment — 'As I had not any concern in putting him in the stocks the first time.' The mayor did it because of 'The regard I had in supporting the dignity of magistracy, and prevent for the future any contempt that might be thrown upon it. I say, if the public are offended, or have the least reason to find fault why such a man, who pays no regard to our laws, nor to the power or dignity of magistracy — but shall be suffered or allowed to vilify and abuse in the manner he did, before several hundreds of witnesses.

'To satisfy them, I acknowledge his being whipped in the House of Correction and exposing him in the manner I did, was for abusing me at my door, before hundreds of country and townspeople, and for telling me I lie. . . .

'And as for his being kept in the House of Correction for seven days, he swore several oaths and curses before me, and when I asked him to pay for them, it was impossible for him to pay who had no money.

'All these and many more provocations which I was obliged to stand and hear (as I could not get a constable for more than half an hour) was the cause of what I ordered to be done to him, and also for appearing before me drunk.'

We can only assume that Hollingworth learned his lesson and stayed away from the mayor's front door in future.

Riding
The Stang

I T was customary in many parts of England until the end of the 19th century, and later in some areas, for rural communities to punish errant husbands and wives who offended in any way against the village standards of honesty or morality, with a special emphasis on sexual offences or disharmony. In Nottinghamshire the punishment appears to have been reserved mainly for wife beaters.

The tradition had several names, including Skimmington, Riding Skimmerton, Rough Music, the Ran-Dan and Riding the Stang, the latter being well known in several Nottinghamshire villages. By whatever name, the treatment usually had the desired effect of humiliating the offender and possibly driving him or her away.

It is believed that Rough Music is an ancient custom, quite likely stemming from pagan times when people believed that fertility was undivided. The power which controlled the crops controlled mankind. If relationships between the sexes were not good it would have implications upon the fertility of the land.

The simple but harsh treatment was carried out at night when the villagers paraded through the streets playing their 'rough music' on tin kettles, horns and saucepans or anything of a percussive nature. They were usually accompanied by an effigy of the miscreant which they

pushed in a cart. The onomatopoeic 'ran, tan, tan' refrain blended beautifully with the rhythm of the so-called musical instruments.

Amidst the din of the 'music', verses would be shouted out referring to the incident which had necessitated the punishment. The following are a few examples of Stang Riding doggerel said to have been used in Nottinghamshire:

'With a ran, dan, dan,
Sing o' my owd tin frying pan,
A brazened-faced villain has been paying his best
 wo-man;
He neither paid her wi' stick, stake or a stower,
But he up wi' his fisses an' he knocked her ower.
 With a ran, dan, dan.'

In this instance 'paying' meant hitting or beating. Another verse on the same theme was:

'Mestur So-and-so has been beating his good woman,
We doesn't know the reason for what nor for why;
But its supposed she wannut eat
Cold cabbage when she's dry.
 To my ran, tan, tan.
He paid her head, he paid her side,
An' that's the reason wey do ride,
 With a ran, tan, tan.'

The phrase 'wannut eat cold cabbage when she's dry' meant the woman would not tamely accept the storm of abuse her husband bestowed with his tongue, but retaliated in kind; hence the 'paying' process given by the brutish husband.

Similar treatment was doled out to a wife beater in a village some three miles from Southwell in 1830. After going around the village the effigy was brought to the door

of the house of the offending husband and set on fire.

Members of the Caunton Women's Institute recorded two verses of the 'Rang-Tang' in *The Nottinghamshire Village Book* which was published in 1989. Some of the older women could remember the custom being enacted. However it would appear that on this occasion the villagers condoned 'Hodge Podge's' behaviour because he had a nagging wife. Perhaps both man and wife were put to shame.

> 'There is a man in our town
> Hodge Podge is his name.
> He's been beating his good wife
> Don't you think this a shame?
>
> It's not because she's icy
> It's not because she's lame.
> She wants to wear the breeches
> That's her little game.'

It was generally supposed that if the Ran-dan was performed on three successive evenings, proceedings could not be taken against anyone. In his book *Notes About Nottinghamshire*, C. Brown wrote of this belief, 'Those who get up the entertainment may say this to induce hangers-back to come forward, but most people think, if it is properly gone through, they are safe from any consequences attending a breach of the peace.'

The
Roeites
of Calverton

JOHN Roe was baptised at Calverton church on 16th July 1732 and brought up in the faith of the Church of England. In the middle of the 18th century many of the local parishioners seem to have fallen out with their vicar, Rev Maurice Pugh, and it may have been this which led to the formation of the Calverton Roeites in about 1785.

The movement was formed by John Roe and styled loosely on the Quaker religion. They sometimes referred to themselves as 'Reformed Quakers', but were popularly known as 'Deformed Quakers'.

A Mr J. Morley of Calverton had a letter printed in the *Nottingham Journal* dated 31st March 1787 stating that he had heard Pastor Roe preach some 20 times. He stated that:

> 'Their religion, in short, is a heap of inconsistencies promiscuously jumbled together, and their preaching an invariable compound of railing, absurdity, Billingsgate and blackguardism. . . . They affirm that John Roe, their founder, holds himself as the only true prophet since the days of the Apostles, and he bitterly inveighs against all denominations, and d--ns the world in a bag. . . . And I need not hesitate to aver, that the wickedness, blasphemy, and abomination delivered from Roe's pulpit, are without parallel.'

The Roeites had a strange attitude towards marriage, which was not solemnised by a traditional wedding ceremony. There was to be no courtship and marriage had to be by ballot. A jury of twelve members was selected, who had to declare if they knew of any objectionable matters regarding the parties. It was especially important that they knew of no courtship between any candidates. If all was well at that stage, lots were cast for wedlock and all drawn cards had to be honoured, no matter how preposterous the result.

Resulting from this tenet two of their members, 'Mrs' Roe, the putative wife of Pastor Roe and her sister 'Mrs' Bush were jailed for twelve years for their faith. Both women's cases were similar.

Mrs Bush became pregnant soon after her 'marriage' and the overseer of the parish determined to make her feel the exercise of his authority. Obviously the parish authorities did not recognise the Roeite 'marriages', but as a single woman Mrs Bush's child would be a burden on the ratepayers. He accordingly took her to a magistrate, to compel her to name the father of her child, but she declared that she was a married woman. By naming the father of the child, he would have been forced to maintain it rather than the parish. She was adamant in her refusal to comply with the magistrate's orders and so was driven knee-deep in snow to Southwell House of Correction, where under the care of keeper Adams, a man known for his sadistic cruelty, she gave birth in a room with an unglazed window, through which the snow flakes blew onto her bed of straw.

In time she was sent home but soon received a citation from an ecclesiastic court, which she ignored. She was carted off to Nottingham County Gaol, to join Mrs Roe, and although every Parliamentary and other effort was made to gain the sisters' freedom, the answer was invariably the same. The children must be fathered, and the request was always refused.

106

The two women languished in gaol and the Bishop of York determined that in order to prevent them from becoming Roeite martyrs, which would do considerable damage to the Church of England, he would connive at their release.

In 1798, when part of the gaol was being rebuilt, the doors of the women's cells were left open and heavy hints made that no-one would see them escape. The sisters took advantage of the situation and the next day the gaoler packed up their goods and collected his fees.

The historian Blackner wrote, 'Although it is impossible not to sympathise with these objects of spiritual vengeance, in the sufferings they endured, yet we must condemn the prejudice which gave these sufferings birth. Often has the writer of these pages heard these women sigh for liberty, and, with the same breath, glory in the persecution they underwent; as though they expected their heroism to be the title-page to eternal fame. But how vain is that heroism which brings nothing but trouble in its train, and which holds up bad example as a mirror to public view.'

The movement appears to have confined itself to Calverton, where Pastor John Roe preached until he reached the age of 91 years. He was a small, venerable looking man, with shoulder length hair the colour of driven snow. Being the keystone of the movement, numbers slowly dwindled after his death.

The chapel where he preached was no more than a barn and was eventually taken over by the Primitive Methodists when the small number of Roeites could no longer maintain the building. It was sold in 1907 and the sect's burial ground has now been completely covered over.

John Roe's name also lives on horticulturally, for he developed a particularly fine plum, which is still grown locally.

The Miller
of Mansfield

THIS traditional tale is based upon an old Nottingham ballad and has a plot redolent of pantomime. There is a mistaken identity and a misdemeanour, forgiveness, poverty which turns to wealth and a love so true that it will not be compromised by riches and beauty.

King Henry VIII enjoyed the chase and one day he and his noblemen were hunting in Sherwood Forest. They were so taken up with their sport that they did not notice the setting sun. Night fell and the king became detached from his party. He wandered wearily through the forest, fearing the dark and possible encounters with thieves and murderers who frequented the area. Fortunately he met a miller from Mansfield, called John Cockle. He asked the man to tell him the most direct route to fair Nottingham. The miller made it quite plain that he mistrusted his motives.

The king demanded to know upon what the miller had based his hasty judgement. He was told that he looked like a gentleman thief and if he did not make haste the miller would crack his knavish crown. The king denied all charges, but still kept his true identity concealed.

'Thou has not,' said the miller, 'one groat in thy purse; all thy inheritance lies on your back.'

Henry replied that he had sufficient gold to meet any occasion and after further assurances of innocence, the

miller took the king back to his house. The miller's wife offered the visitor food and a share in her son's humble bed.

Dame Cockle supplied a hearty meal of hot bag-puddings, venison pasty and apple pies, all washed down with a large bowlful of good strong ale. The hungry king devoured the food with great gusto and proclaimed that he had never eaten anything so good and where could he purchase such delicious venison pasty?

Richard the son laughed and said that the venison cost them nothing as it was filched from the king's stock of deer which roamed about Sherwood Forest. Their guest was told to keep their guilty secret to himself and he swore his compliance.

The miller's wife busied herself with laying out fresh bed straw, on top of which she placed her best brown hempen sheets, in honour of the visitor. The men comforted themselves with several cups of 'Lamb's Wool', made from good nut brown ale and finished off with roasted crab-apples, sugar, nutmeg and ginger, and soon after were in a sound sleep.

The next morning the remainder of the hunting party searched the area for their leader and found him just as he was mounting his horse and bidding farewell to John Cockle and his family. The noblemen fell to their knees before their monarch and the Cockles quaked in their shoes. The miller was convinced that he would be hanged for questioning his majesty's character and poaching his game. He begged for mercy and the king laughed heartily and conferred a knighthood on the hospitable Miller of Mansfield.

Back in Nottingham, with plenty of ale in his belly, the king recounted his adventures, but nothing could compare with the sport he had found in the company of the Miller of Mansfield.

Sir John Cockle went about his usual work at the mill and nobody believed his newly elevated status. He still looked

the same poor John, dressed in his smock and dusted with flour.

Upon the king's return to London word was sent to his newest knight and his family, desiring their company at court. The puzzled miller received the summons with caution, thinking it was some jest from his farmer friends who had been teasing him remorselessly about his supposed meeting with the king.

His fears were allayed by a token from the messenger and his assurance that he and his family were to be guests of honour at a feast. The Cockles' hearts froze. They were poor people. How should they behave? How should they get to London? The expense of it all! Dame Cockle would need a new gown. They must have good horses and serving men!

In the end the good wife trimmed up her old russet gown and they rode to court on the mill horses. Master Cockle went on ahead, cutting quite a dash with a cock's feather stuck in his hat.

The king warmly greeted the strange crew from Mansfield and bade them welcome at his court. A huge meal was set out which included a venison pasty similar to the one which had graced Dame Cockle's table. Sir John and his lady blushed with shame and their son refused to eat it exclaiming, 'Ho! Ho! 'tis knavery to eat it, and then betray it.'

After the feast it was time for dancing. The clodhoppers from Nottinghamshire provided the main entertainment for the noble assembly, who watched dumbfounded and feared for their feet as the trio charged around in shoes more fit for killing vermin than tackling a courtly dance.

As the Cockles were on the point of departure the king asked Richard if he would like to choose a wife from one of his beautiful, rich and unattached guests. The lad looked the king straight in the eye and replied, 'Jugg Grumball, sir, she's my love, and only her will I wed.'

And so they returned to their home town, John to his

111

new appointment which had just been awarded by the king, at a salary of £300 per annum. He was no longer to be the poor Miller of Mansfield, but instead the wealthy overseer of Sherwood Forest. Dame Cockle returned to her cooking, but as ordered by the king she used a different filling for her pasties. Richard pledged his troth to Jugg Grumball and presumably, in keeping with most traditional tales, they all lived happily ever after.

Plough Bullocks

PLOUGH Monday, for many farm labourers, was one of the most important days in their calendar. Throughout England it was on Plough Monday, being the first Monday after Epiphany, that the ploughmen returned to work after the Christmas holiday. It was also traditional centuries ago for the farmworkers and domestic servants to rise especially early on that morning. If the ploughman could get any of his tools laid out in front of the fire before the servant could boil her kettle, she forfeited her 'Shrovetide Cock' which was fattened and killed to celebrate that occasion.

Thomas Tusser (1524–1580), the rustic poet, advises:

> 'Plough Monday, next after that Twelfthtide is past,
> Bids out with the plough, the worst husband is last,
> If ploughmen get hatchet, or whip to the screen,
> Maids loseth their cock, if not water be seen.'

It is quite likely that in many areas of the country very little work was ever done on this day, for it was the custom for the men to hold wonderful revels to celebrate the start of the new working year.

Some communities did this throughout the day and night, others reserved their fun for the evening. Most of the ploughmen and boys called on the large farms and houses, plus selected public houses, with a tin to collect their largesse — miserly people were invariably punished

in a most humiliating fashion. Other groups performed Mummers Plays or Plough Monday Plays, again with their collection tin at the ready. For many people this was their first introduction to 'costumed actors'. Old school log books record a high rate of absenteeism as pupils followed the jolly ploughboys, witnessing a lot of the grown ups getting up to tricks for which they as children would have received a good beating.

It was further customary for some of the ploughmen to dress up as parodies of women. In Nottinghamshire the men and boys were generally known as 'Plough Bullocks', where the air was raucous with the sound of rattling tins and the cry, 'Remember the Plough Bullocks!'

Some of the Nottinghamshire men took a great deal of time with their 'cross dressing'. The following description is given by J. Potter Briscoe, a prolific Nottinghamshire writer of the latter part of the 19th century. 'The vainest lady in the land could hardly take more pains in the arrangement of her attire than did some of these "Bullocks". Paints, feathers, strange clothes and other articles were brought into active requisition, and when the wearer appeared at last in the full splendour of his costume — a strange gaunt figure, with sundry tufts of feathers, and armed with a thick bludgeon — he looked the facsimile of an Indian chief in full battle array.'

In whatever part of England the celebrations took place the participants invariably disguised themselves by blackening their faces with soot, which had a horrible stinging effect on their skin. They obviously did not want to be individually accountable for their misdemeanours on Plough Monday! It was usual for them to pull either an old or a mock plough behind them which was dragged over the gardens of any misers who refused to fill their tin.

It is believed that the Plough Monday revels are the remains of fertility rites once performed on that day to celebrate the beginning of a new season's harvest and to ensure its bounty. The jumping and skipping of the Morris

dancers and some of the Plough Men, and their 'changing sex' by wearing women's clothes, have definite fertility associations. The ploughing is symbolic of the next harvest season.

Many of the Nottinghamshire 'Plough Bullock Day' plays, which included a character called Tom Fool, ended with a variation of the following chorus:

'Good master and good mistress
You see our fool is gone.
We'll take it in our turn now
To follow him along.
We thank you for civility
And what you've given us here
We wish you all prosperity
And another happy new year.'

Plough Monday often resulted in total mayhem throughout the day and drunken behaviour at night when the collecting tin was emptied. By the end of the 19th century or beginning of the 20th, most celebrations had ceased, often on the orders of the local magistrates.

The Bessie Sheppard Stone

IF you travel along the A60 almost mid way between Ravenshead and Mansfield, you will find a memorial stone standing at the southern edge of Harlow Wood. It bears an inscription to Bessie Sheppard, who was murdered on that spot in 1817.

It was on the 7th July of that year that 17 year old Bessie left her mother's house at Papplewick, south of Ravenshead, to walk into Mansfield in search of domestic work. She set out at mid-day dressed in her new shoes and carrying a light coloured cotton umbrella.

The last sighting of her was round about six o'clock when she was seen leaving Mansfield and heading for home, but the poor girl never reached her destination. The hours passed by and Mrs Sheppard's earlier annoyance at the lateness of her daughter gradually turned to a foreboding that something dreadful had happened. The night grew dark, as a search party scoured the area without results.

The young girl had left home in good spirits, optimistic of finding work at Mansfield, and there was no reason why she should go missing of her own accord. She was an uncomplicated, hard working girl with no apparent secrets. The hours dragged by until the morning, when her mother's worst fears were confirmed. Bessie's body was

found lying in a ditch by the roadside, 'about 50 to 60 yards south of the third milestone.' Her skull was brutally fractured and a large hedgestake lay close to her crumpled body. The deadly instrument was later produced as evidence in court, still clotted with blood, 'and a thrill of horror ran through the spectators.'

Charles Rotherham of Sheffield, aged 33, a one-time apprentice scissors grinder turned soldier, was arrested shortly after and charged with Bessie's murder.

Rotherham had been seen drinking at the Hut Tavern close to the scene of the crime shortly after the estimated time when the act was committed. Later he slept the night at the Three Crowns inn, Redhill where he had offered Bessie's shoes and umbrella for sale. As there were no buyers he left the shoes in his bedroom when he moved on at seven o'clock the following morning. The umbrella was eventually sold at Bunny.

He was apprehended at Loughborough and taken by police escort to Nottingham where he made a full confession to the crime. At the trial the police stated that on their journey back from Leicestershire, Rotherham had been able to show them where the killing had taken place, and even took them to the hedge from which he had cut his weapon.

The soldier could not explain why he had killed the girl, whom he had never seen before that fateful day. He just struck her about the head and kept beating her until she was dead. Rotherham explained that he had gone through her pockets in search of money, but had found none. He then cut open her stays in the hope that was where she kept her cash. Her body was searched in vain and so he settled for her new shoes and umbrella, which had finally incriminated him.

A verdict of guilty was pronounced on 25th July 1817 and he was hanged at Gallows Hill, Nottingham, three days later in front of a huge jeering crowd. The Rev J. Bryan gave a long address to the onlookers who were eager for

117

their entertainment to begin. He then prayed with the prisoner who was suitably launched into eternity, to the sound of great public rejoicing.

Rotherham's body was cut down and taken to the County Hall for the customary dissection by surgeons. When they were done the remains were put on public view in the Nisi Prius Court and eventually buried at the back of St Mary's church.

To perpetuate the memory of this tragedy some businessmen from Mansfield erected a stone on the site where the murder took place, with the following inscription:

'This stone was erected in memory of Elizabeth Sheppard, of Papplewick, who was murdered by Charles Rotherham, near this place, on the 7th of July, 1817, aged 17 years.'

The
Boy of
Nottingham

THERE is very little recorded witchcraft in Nottinghamshire, but an interesting tale is that of a young lad who was to become known as the 'Boy of Nottingham' and a charlatan exorcist named the Reverend Darrell.

At the end of the 16th century, William Somers was apprenticed to a town musician. He hated his master and his work, so he used to fake sickness in order to stay away. Somers would drink huge quantities of cold water to make his belly swell and then roll on the floor in agony. The trick worked and the artful boy added more to his repertoire and began to ape possession by devils.

His neighbours were intrigued by the youth and bought copies of the pamphlet concerning the 'Witches of Warboys' from Huntingdonshire. That case came to light in 1589 and had a familiar ring to what was happening in Nottingham. The Huntingdonshire case had attracted a lot of attention as it involved money and influence in the shape of Lady Cromwell, one of the wealthiest women in England and the grandmother of Oliver Cromwell, and Squire Throckmorton of Warboys. The apprentice's fits were similar to those of the Throckmortons' daughters and servants who were supposedly possessed by witchcraft.

William got hold of a copy, which fed his fertile imagination and he consequently claimed bewitchment 'by an old woman that he had met with, because he had not given her a hat band he had found.'

Unwittingly William Somers' life was soon to change as his conduct led him closer and closer to the influence of the Reverend John Darrell.

Darrell was a Nottinghamshire man, and had been educated at Cambridge. Upon returning to his home town, Mansfield, he became a freelance preacher. He also performed many dramatic exorcisms all over the Midlands whereby he expelled evil spirits from those who were possessed. He usually worked in front of a large crowd, who were both shocked and entertained by his incantations and the contortions of his subjects. The latter could be relied upon to throw hysterics and writhe on the ground in various stages of agony. Some would speak in strange voices and vomit up weird artefacts. It was normal for a collection to be taken at the end of the exorcism, which was money well spent to see John Darrell at work. Much of what he did was later proved to be a hoax. He was given a warning by magistrates and threatened with future imprisonment.

Then on 5th November 1597, he was invited to exorcise young Somers, but we are not told by whom.

He took William aside and explained that his case was very similar to that of Thomas Darling of Burton, whom he had exorcised in front of a great gathering. Tommy had made accusations about two women, Alice Gooderidge and her mother Elizabeth Wright, whom he alleged had bewitched him. The boy had lost his way in the woods and had behaved in an anti-social manner when he passed the two women on the pathway. Both women cursed him and this subsequently resulted in fits whereby he foamed at the mouth. Darrell reeled off many lurid descriptions of possession which he had subsequently dealt with. The case of Thomas Darling was later proved to be fraudulent.

William Somers was a willing pupil and his symptoms immediately increased at an alarming rate.

At a public meeting the next day Darrell informed the large crowd that the young boy suffered for the sins of all Nottingham. He was in fact the 'Boy of Nottingham', and bore the weight of all their misdemeanours on his young shoulders. He urged them to fast on the following day and exhorted the men to 'refrain from the company of their wives that night'. In return for their abstention they would see strange things the following day.

Two days later the exorcist preached a long sermon in front of a full congregation at St Mary's church. He listed 14 signs of possession which his student, William, innocently displayed:

'Firstly, the bewitched desire the worst food.' The boy immediately screamed out for something disgusting to eat, which was miraculously close to hand. The onlookers were reviled as he crammed it into his mouth.

'Secondly, they are unable to retain their food, are irked by continual vomiting, and are unable to digest.' William was obligingly sick and bent double with pain, moaned and howled like a sick animal.

'Thirdly, the bewitched have trouble with their heart, which feels as if torn by dogs, or eaten by serpents. . . .' William clutched himself in the region of his wicked heart.

'Fourthly, some experience frequent and sudden pains, which they cannot describe, but they shriek aloud.' The Boy of Nottingham was right on cue.

The crowd loved it and stood in silence, gasping when the actors played a particularly fine scene. The exorcist and his assistant finished their 14 turns and it was time for the exorcism to begin.

Darrell fixed his eyes firmly on Somers and laid his hand on the boy's head. Then he gave a secret command to the Devil, the Devil being the originator of the evil. Then he made a certain sign and in a loud voice began: 'As a minister of Christ and the Church and in the name of Jesus

Christ, I command you, unclean spirit, if you lie in the body of this man created by God. . . .' Finally the boy was freed from the malevolent influence and the customary collection was taken.

Cunning Darrell left room for further manipulation by stating in a very stern voice that although the boy had been delivered from all that was unholy in Nottingham, he was not free from danger. The Devil could return to him at any time in the shape of a bird, a toad, a set of dancers or even an angel. Between them they kept the pot boiling by Somers showing signs of possession at suitable intervals, and thereafter being exorcised in public in the flamboyant style expected from the freelance preacher from Mansfield.

The Boy of Nottingham's next ploy was to accuse Alice Freeman and twelve other women of causing him fits by witchcraft. They were carted off to Nottingham gaol but only two were eventually brought to trial.

Darrell condoned the boy's accusation, but Alice Freeman was the sister of an Alderman, who suspected all was not as it seemed between Darrell and Somers and had the latter taken to the House of Correction for questioning. The Boy of Nottingham confessed that his possession by the Devil had been a fraud and that he had acted under the tuition of the exorcist. This was a very serious accusation to make against a minister, and a report was made to the Archbishop of York, who set up a commission of enquiry.

Upon further examination Somers retracted his confession and went into a series of such violent fits that the enquiry believed him to be possessed.

Alice Freeman was brought to trial before Sir Edward Anderson, who had already had dealings with Darrell in the past. He urged Somers to tell the truth and William confessed again that he had been lying. The case was dismissed and a report made to the Archbishop of Canterbury.

Darrell was taken to Lambeth and examined by the

Archbishop, the Bishop of London and others. Thomas Darling, one of his earlier assistants, and William Somers both gave evidence against him and confessed that their fits and subsequent exorcisms were all fakes. They had both been taught by Darrell in the art of deception.

Darrell was stripped of his living and sent to gaol for a year where he wrote vigorous protestations of wrongful imprisonment. Many influential people continued to believe in his innocence long after his release from imprisonment, but his careers as a minister and an exorcist were both over.

However, his most permanent memorial is said to be the 72nd Canon of the Canons of London drawn up by Bishop Bancroft in 1604, which forbids any Church of England minister without prior permission by his bishop, to 'attempt upon any pretence whatever either of possession or obsession by fasting or prayer, to cast out any devil or devils, under pain of the imputation of imposture or cozenage, and deposition from the ministry.'

Bibliography

The Nottinghamshire Village Book,
Nottinghamshire Federation of Women's Institutes
Countryside Books.

Stories about the Midlands
By J. Potter Briscoe.

Old Nottingham
By J. Potter Briscoe.
Published by Hamilton, Adams & Co.

Notes About Nottingham
By C. Brown.

Nottinghamshire Facts and Fiction
By J. Potter Briscoe.

All about the Merry Tales of Gotham
By Alfred Stapleton.
Published by R. N. Pearson.

Notts and Derby Notes & Queries
Edited by J. Potter Briscoe FRHS.
Published by Frank Murray.

The Encyclopedia of Witchcraft and Demonology
By Rossell Hope Robbins.
Published by the Hamlyn Publishing Group Ltd.

Witchcraft in England
By Christina Hole.
Published by Batsford.

Highway & Byways of Nottinghamshire
By J. B. Firth.
McMillan & Co.

Food in England
By Dorothy Hartley.
Futura Publications.

The Pattern Under the Plough
By G. Ewart Evans.
Faber & Faber.

English Sports and Pastimes
By Christina Hole.
Batsford.

Robin Hood
By J. C. Holt.
Thames and Hudson.

On the Trail of Robin Hood
By Richard de Vries.
Crossbow Books.

Walkabout the Lace Market
By Doug Ritchie.
Papyrus Books.

Lord Byron
By Elizabeth Eisenberg.
J. H. Hall & Sons Ltd.

The Great Nottingham Goose Fair
By Peter Wilkes.
Trent Valley Publications.

BIBLIOGRAPHY

Then and Now
By R. Mellows.
J. & H. Bell.

A History of Nottinghamshire
By A. C. Wood.
Cooke & Vowles (1940) Ltd.

Nottinghamshire Library Scrap Books.

Memorials of Old Nottinghamshire
Edited by Everard L. Guilford, M.S.
George Allen & Company.

The White Horse of Newstead Abbey and its Rider
Reprinted from the Mansfield Reporter.

The Date Book of Nottingham 1750–1850
By John F. Sutton.

The Penny Magazine

Various press cuttings from the
Local Studies Department of
Nottinghamshire County Library.